IMAGES
of America

NEWPORT NEWS

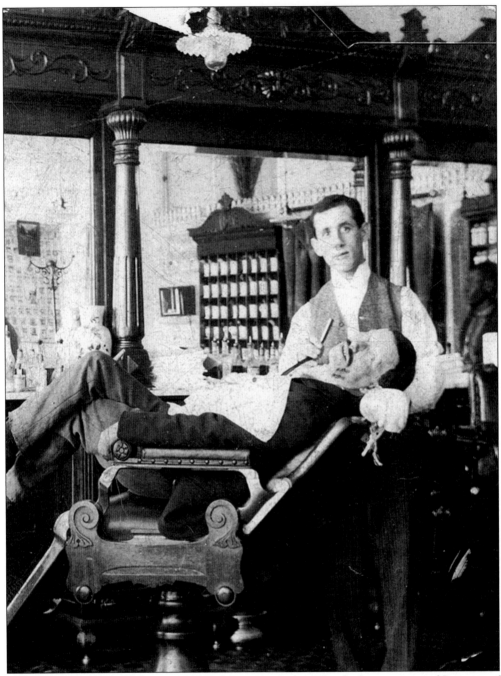

Jacob Brenner's Barbershop was used as the voting precinct for the business area. (Courtesy of the Jewish Historical Society, 1898.)

IMAGES
of America

NEWPORT NEWS

Jane Carter Webb

ARCADIA

Published by Arcadia Publishing
an imprint of Tempus Publishing Inc.
Charleston SC, Chicago, Portsmouth NH, San Francisco

Printed in Great Britain

Library of Congress Catalog Card Number: 2003111361

For all general information contact Arcadia Publishing at:
Telephone 843-853-2070
Fax 843-853-0044
E-mail sales@arcadiapublishing.com
For customer service and orders:
Toll-Free 1-888-313-2665

Visit us on the internet at http://www.arcadiapublishing.com

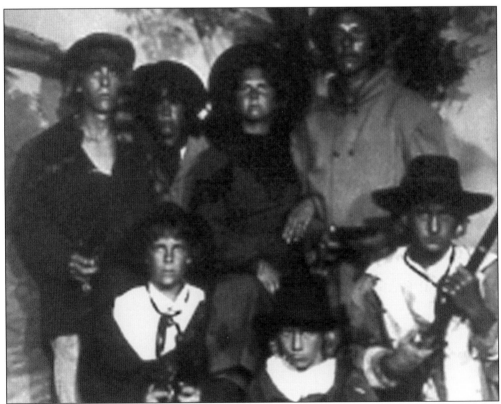

These solid citizens of the Peninsula pose for the photograph. Those pictured, from left to right, are E.L. Monroe, C.S. Blandford, G.R. Webb, A.M. Wilson, M. Rauch, W.R. Van Buren, and L.W. Webb. (Courtesy of the Webb Collection.)

CONTENTS

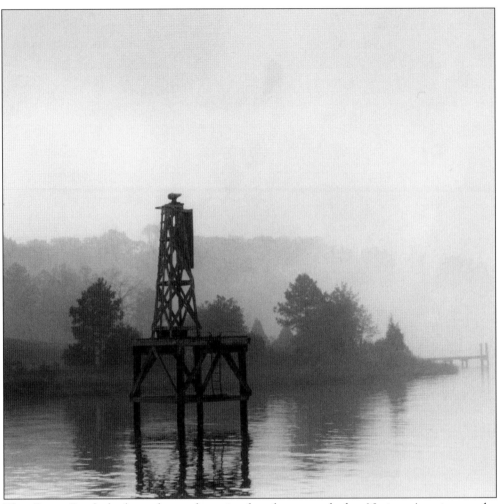

The Deep Creek harbor, shown here in fog, has served the Native Americans, the early colonists, the oyster fleet, and now the pleasure boaters. (Courtesy of the Webb Collection, 1978.)

ACKNOWLEDGMENTS

The two of us have worked as a team in nearly everything we do for many years, and this book is not an exception. It gives us the opportunity to thank you, the people of the Virginia Peninsula, for welcoming us and our children over 30 years ago, for making us a part of your community, and for letting us teach you, your children, and a few of your grandchildren both physics and sailing. You do build good ships but you build even better friendships. We give special thanks to Alexander Crosby Brown and Robert H. Burgess for opening to us ties to the river and the bay that make our region special.

Jane and George Webb, 2003

INTRODUCTION

In the spring of 1607, three wooden sailing ships headed up a wide river. On board the ships, which were commanded by Capt. Christopher Newport, were the colonists planning to make a foothold in the New World. Newport had orders from King James of England to sail far enough up a river to allow the colonists to watch and prepare for attack by the Spanish. It is probably for that reason that Newport rounded the tip of the peninsula and headed upstream to the area that would become Jamestown.

Although neither the colonists nor Newport could have known it, Jamestown was one of the worst spots they could have picked. Low lying, marshy, with brackish water, the site brought a host of problems, not the least of which was the lack of fresh water. It is not a surprise to find that the Englishman with what is thought to be the oldest grave marker in the United States met his fate in the area. He was killed by an irate Native American while in Newport News, looking for water.

Water was not the only reason the settlers went down to Newport News. At the tip of the peninsula, they could look around into the Bay, hoping to see Christopher Newport's ships returning with promised supplies and perhaps new colonists. One can hear them asking the watchers, "What news hath you of Newport?" Two years and 440 deaths later, the remnant of 60 Englishmen got news of Newport. His return was delayed due to a shipwreck off the coast of Bermuda.

The years rolled by. For a short while, what would one day be Newport News was part of Elizabeth City. The area then became part of Warwick County, and thus it remained through the battles of the revolution, the coming and the going of farmers and planters, and even the Civil War. In 1880, Newport News was a sleepy fishing and farming community. Residents had no idea that life was about to change. The man who would transform the village was Collis P. Huntington.

Huntington had wandered through eastern Virginia when he was a 16-year-old peddler in 1837. By the end of the Civil War, Huntington had thrived. He was a rich and ambitious railroad magnate who was determined to build an eastern terminus for his transcontinental railroad. He was careful to choose a site at the furthest north deepwater port that did not freeze in winter. The neighboring towns of Norfolk and Hampton were eliminated because their waterfronts were developed. Newport News was the perfect candidate for Huntington's plans.

Through the Old Dominion Land Company, situated in a humble building north of the village, Huntington bought numerous waterfront properties, all purchased without the

knowledge of the local townspeople. Structures were built on the waterfront and rail was laid. On May 1, 1882, the Chesapeake and Ohio Railway began regular service to Newport News.

Huntington was not finished with his development of the area. Huntington's interest in the region remained for several different reasons, the chief of these being Arabella Yarrington. When Huntington first came to the area, he lodged in Richmond and met the young woman. He moved Arabella to New York, where he was based. In 1870, Arabella gave birth to a son whose putative father was John Worsham. Arabella and her son, Archer Milton Worsham, lived in opulent quarters set up by Huntington. She helped nurse Mrs. Huntington, who was dying slowly of cancer. In October of 1883, Huntington's wife died. In July of 1884, Huntington married Arabella and formally "adopted" her son, Archer Milton Huntington. This was not his first adopted child. Huntington had previously adopted his first wife's niece, Clara. When Arabella became part of the family, she and Clara got along beautifully. By 1893, Arabella had finished a magnificent house on the corner of Fifth Avenue and 57th Street. The house stood where Tiffany's stands today. One can see that the attention Collis gave to Newport News had something to do with Arabella, and, later, with the interest their son showed in the development of The Mariners' Museum.

By 1896, Newport News became incorporated as a city. Collis P. Huntington brought in an architect, and they laid out the town for immediate development and beyond. It was the planning of the Huntington family that produced an industrial heart surrounded by residences of increasing splendor. All of this planning would lead to a greenbelt, reservoir reserves sufficient for the needs of the city, and the rise of Newport News shipbuilding, which under a variety of names and owners has served the nation well.

Newport News started the 20th century almost as a frontier town and in slightly more than a hundred years—through stages of chaos and order—has become a thriving city.

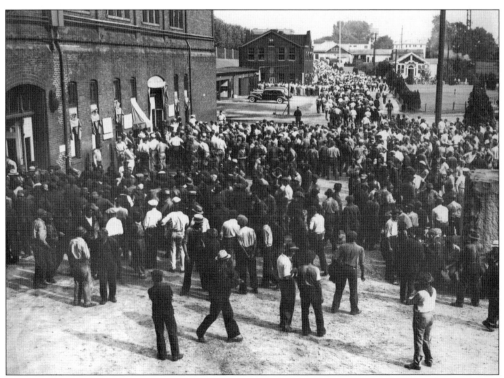

Shipyard workers line up to get their pay. (Courtesy of Hampton Roads Chamber of Commerce, c. 1930.)

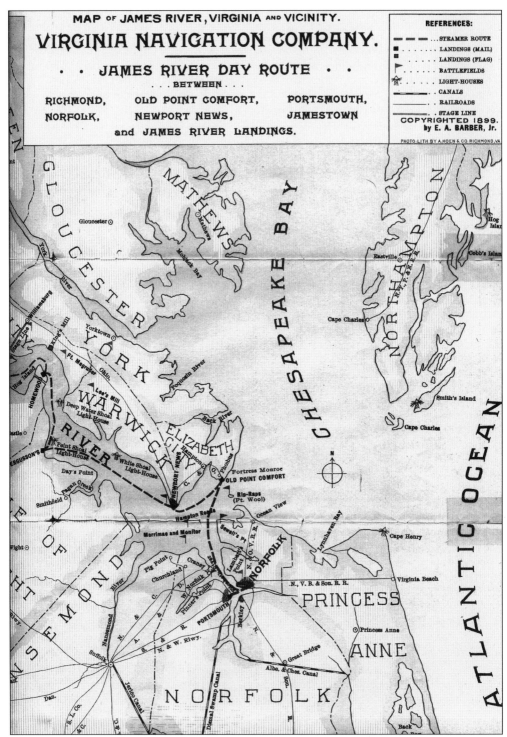

MAP OF JAMES RIVER, VIRGINIA AND VICINITY.

VIRGINIA NAVIGATION COMPANY.

· · JAMES RIVER DAY ROUTE · ·

... BETWEEN ...

RICHMOND, OLD POINT COMFORT, PORTSMOUTH,

NORFOLK, NEWPORT NEWS, JAMESTOWN

and JAMES RIVER LANDINGS.

REFERENCES:

----- ..STEAMER ROUTE
....... LANDINGS (MAIL)
....... LANDINGS (FLAG)
....... BATTLEFIELDS
....... LIGHT-HOUSES
....... CANALS
....... RAILROADS
....... STAGE LINE

COPYRIGHTED 1899.
by E. A. BARBER, Jr.

PHOTO.LITH BY A.HOEN & CO. RICHMOND, VA

This 1899 map shows a portion of the James River route of the palace steamer *Pocahontas*, which knit together 25 communities along the James from Norfolk to Richmond. (Courtesy of the Webb Collection, 1898.)

10

One

You Can Get There From Here

In the very beginnings of the English settlements in Virginia's Tidewater and for many years after, both people and goods traveled principally by water. Overland trips were tedious and very uncomfortable. As romantic as horses may seem today, jouncing on an animal in the heat, cold, rain, and on uncertain territory must have made the bones of people ache for weeks.

Even in the days before the Civil War, when a young Collis P. Huntington peddled his wares through Virginia, Tidewater's extensive series of waterways made travel much easier. Huntington's ability to learn from his youthful travels and to remember all he learned is impressive. The peninsula where Newport News is located is bounded by both the James and the York Rivers. Both are navigable even with today's larger vessels. Additional smaller rivers form a network, which settlers and their descendants used for commerce as well as personal travel.

Sailing vessels were predominant until steam power took hold. They remained in use during the early years of the 20th century. When Huntington's railway was first completed, beautiful coal colliers were the only means of transporting coal. Coal colliers were wooden ships with impressive straight masts made from native longleaf pine. Similar schooners carried other forms of freight, and there was vigorous commercial trade along the east coast, to England, and to other European ports. Smaller vessels, from log canoes to skiffs, were seen everywhere. They not only served to transport produce but were used by watermen to catch fish and crabs. Oysters, which were present in amazing abundance into the middle of the 20th century, required the development of yet another type of boat.

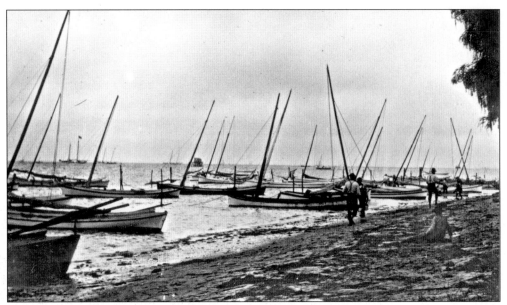

The small boats shown here are beached on the narrow strips of sand that lie at the bottom of the bluffs along the James River. These vessels were probably used as crab boats. (Courtesy of the Webb Collection, 1910.)

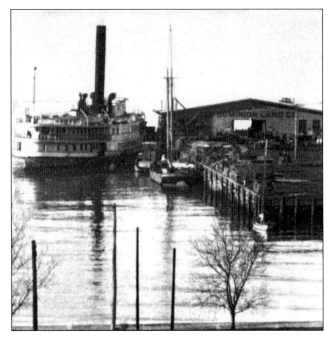

The *Pocahontas*, shown here tied up to the Old Dominion Land Company Pier in 1920, was so elegant she was called a palace steamer. (Courtesy of The Mariners' Museum, 1920.)

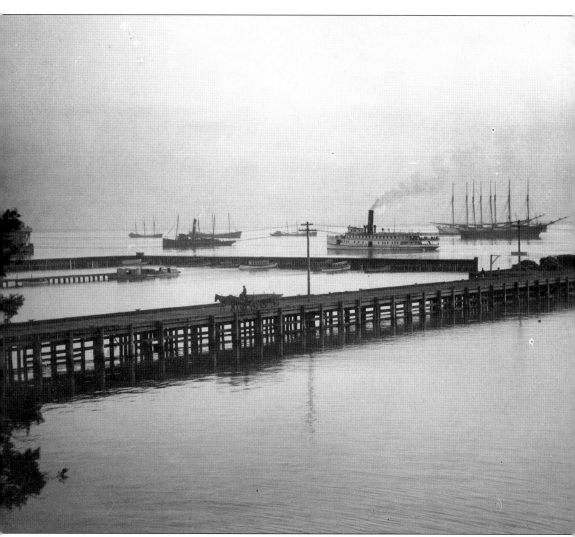

This wonderful picture shows the *Smoky Joe*, the steamboat that ran regularly among Norfolk, Newport News, and Hampton. After she was decommissioned, mourning consumed the residents. Her whistle was preserved, however, and when one day someone attached it to a source of steam, Robert Burgess came running to see whether by some miracle she had been resurrected. (Courtesy of The Mariners' Museum, 1910.)

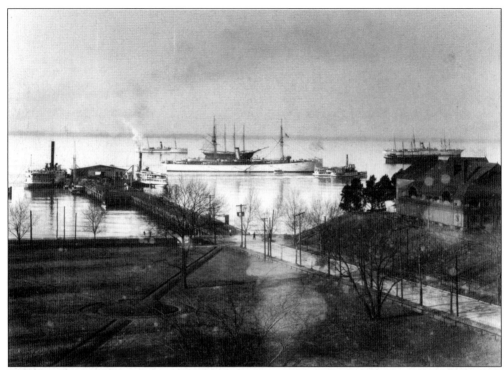

In the early days of her service, the *Pocahontas* shared the rivers and Bay with beautiful sailing vessels that can be seen in the distance. (Courtesy of The Mariners' Museum, 1902.)

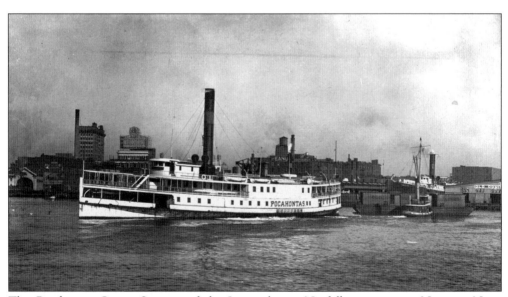

The *Pocahontas*, Queen Steamer of the James, leaves Norfolk en route to Newport News (Courtesy of The Mariners' Museum, 1916.)

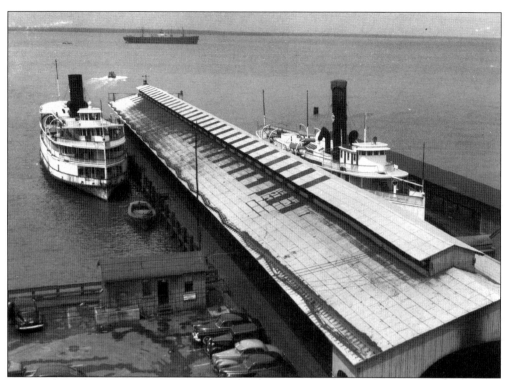

The *Virginia* and the *Wauketa* are shown here tied up at the C&O train pier. (Courtesy of the Webb Collection, photograph by Robert H. Burgess, *c.* 1950.)

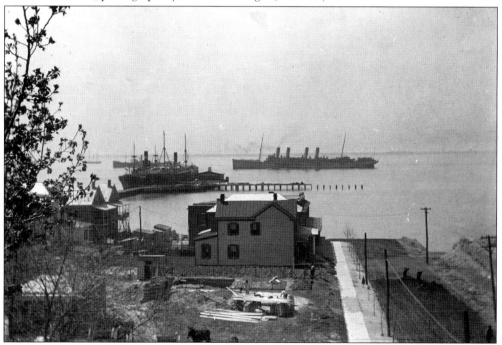

Shown here is a Newport News harbor scene with Warwick Machine Company in the foreground. (Courtesy of The Mariners' Museum, 1920.)

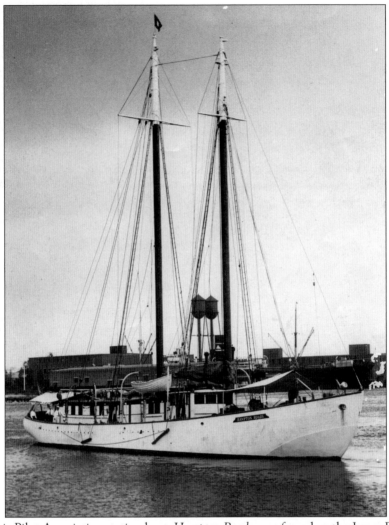

The Virginia Pilot Association station boat, *Hampton Roads*, was forced up the James River into safety by the fierce winds of the hurricane of 1933. (Courtesy of the Webb Collection, 1933.)

THE GREAT HURRICANE OF 1933

The Virginia Pilots are skilled navigators, whose task is to guide ships from the ocean into the Bay, the shallow harbors, up the rivers, and through the shoals. They used to hang out on their station boat, waiting far out in the Bay for the next big ship. The night of this hurricane, their yacht *Hampton Roads* was severely buffeted by the winds. Captain Bush put the boat into the James at four in the morning. The winds were so strong that the boat kept dragging anchor.

Pictured here is the Hampton Yacht Club, c. 1930. Every family that went through this hurricane has its own stories. This one comes from the Norton family. Sue Gray Norton Al-Salam tells of her father's purchase of a barometer near the time of the hurricane. When it showed the pressure was falling drastically, her mother thought it was broken, but her father went to the Hampton Yacht Club and put extra lines on his yacht. The next day, most of the boats were strewn around like toys —except Mr. Norton's. (Courtesy of the Hampton Roads Chamber of Commerce, c. 1930.)

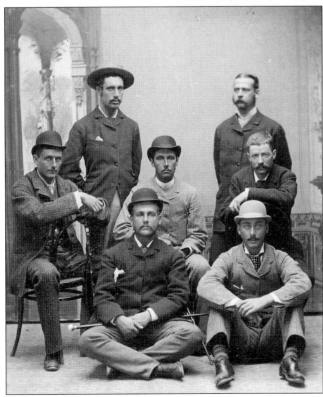

This photograph shows seven early harbor pilots in Newport News. Written on the photo in a neat hand is "The Hoodlum Band." (Courtesy of the Webb Collection, c. 1910.)

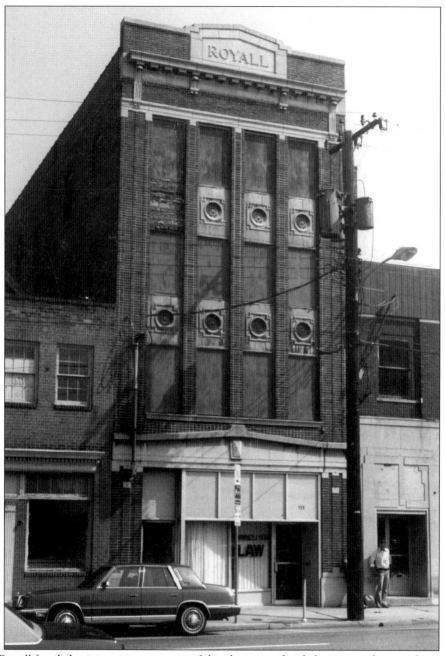

The Royall family business captures many of the elements of early business culture in downtown
Newport News. (Courtesy of the Royall Family Collection, 1990.)

Two

THE BEGINNINGS OF OUR BUSINESS CULTURE

Huntington's development of Newport News, although sparked by the coming of the C&O and the port, was given further impetus by the creation of Newport News Shipbuilding. Huntington had originally thought he would only create a repair yard. As locals know, the wooden ships that then plied the waters required constant upkeep. Huntington brought in craftsmen whose trades supported repair work, from ship riggers to skilled carpenters. A financial panic caused Huntington to re-evaluate his plans. His boldness allowed him to make the next move. Rather than have skilled workers simply engaged in the repair business, he would have them build ships, thus preserving his base of workers. In 1886, the Chesapeake Dry Dock and Construction Company was chartered. Four years later, the name was changed to the Newport News Shipbuilding and Dry Dock Company.

This shift, which would create a Leviathan in the world of shipbuilding, also saw businesses spring up to support the needs of the company, to take care of the workers, and then to provide the people who moved in with goods and services. As a heavy stone dropped into a quiet pond produces ever-expanding ripples, the company created a series of needs that multiplied as the people arrived. The small businesses that came built buildings and warehouses, sold real estate and insurance, offered legal services, and produced the goods (furniture, clothing, eye glasses, shoes, food) necessary for a swelling population. Side by side, the company (later known as "the Yard") and the town grew together. Eventually, the Yard was the largest private employer in Virginia. Newport News became a company town in the sense that the Yard's fortunes were the town's fortunes.

For many years, the mutually supportive relationship between the very large and the very small created a friendly and accommodating culture. This was a culture where a man could expect to prosper if he worked hard and his business or his efforts fit a need. The sturdy independent businessman trusted the Yard, and that trust would be justified for half a century. Perhaps because many of the earliest businessmen were Jewish, the town was considered very tolerant for the late 19th and early 20th centuries. However, Newport News did remain very much a part of the South. The color bar was ever present. With the exception of a few amazing men, blacks were rarely invited to the table of decision-making, government, or politics.

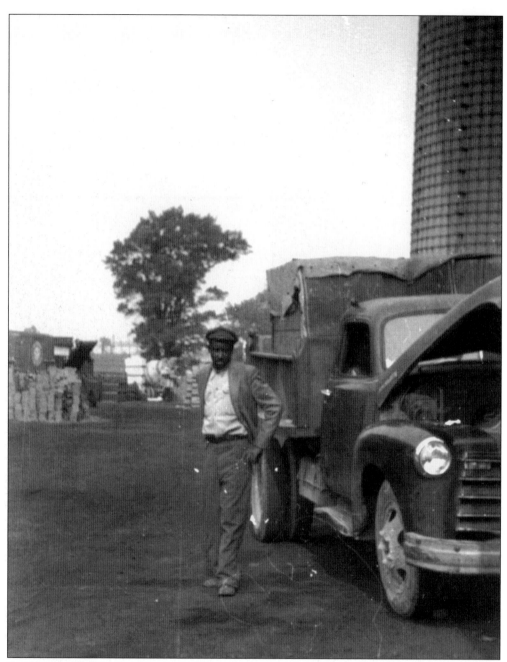

Benson and Phillips, started as a coal and wood supply company, was the first to store coal in silos, one of which appears here behind the workman and his truck. The company was started by Edwin Phillips and Tom Benson in 1891. Their first coal yard, at the foot of the C&O Pier, burned, and they moved to the foot of Warwick Boulevard at 24th Street. "In 1925, Benson and Phillips moved to 3100 Virginia Avenue, as it was known in those days. We developed a mechanical system to get the coal off the trucks, so a man didn't have to shovel it off . . . much neater that way."—E.K. Phillips Jr. (Photo Courtesy Phillips Collection.)

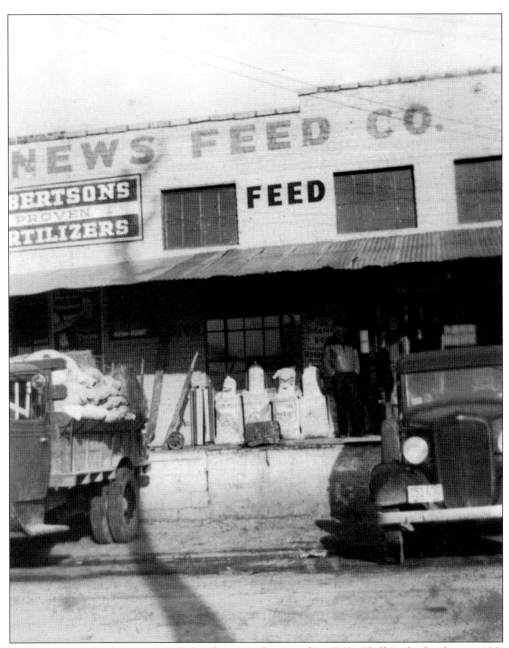

This photograph shows one of the five warehouses that E.K. Phillips built about 1938. According to E. K. Phillips, Jr., "Every time my dad rented a warehouse, he built another one. Billy Mayo, whose family came from Norfolk, managed one of the feed stores and he rented this warehouse." Feed and seed stores sold mainly to local farms, but another major client was the circus. The circus came to the area by train from Richmond and pitched tents in the area near 45th and 46th Streets. (Courtesy of the Mayo family Collection, c. 1940.)

Billy Mayo's grandfather, Theodore Norman Mayo (who lived to become the oldest surviving Confederate veteran in Norfolk), was a distinguished gentleman in Tidewater. On his 101st birthday, Mayo invited a reporter to join him in a little toddy. According to the reporter, Mayo's daughter accidentally poured a full jigger of whiskey for her father. "Oh, my goodness, I need to put half of this back," she said. "That is what I get," said Mr. Mayo. "Put it in the glass." Everyone assembled wished him a happy birthday, and then he raised his glass with a courtly gesture and said, "Well, here's fun." (Theodore Norman Mayo, Courtesy of the Mayo family Collection, c. 1940.)

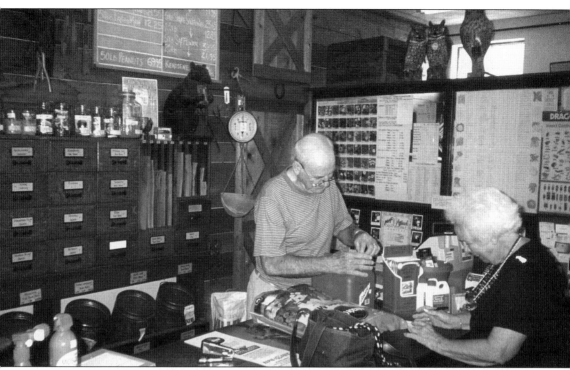

After a time, Billy Mayo decided to go into business on his own and opened Mayo's, a feed and seed store, the interior of which is shown here. Eventually Billy sold Mayo's. Chuck Lilly is the present owner. Much of the interior of Mayo's is quite old. The rear wall contains a collection of antique drawers designed to hold seed. Mrs. Mayo refinished those drawers herself. Chuck Lilly is interested in antique tools and other artifacts related to the original business. These artifacts hang on the wall behind the counter. Children are often intrigued by the enormous wooden rat, once an ad for rat poison. It is immediately above the head of the clerk in the picture. (Courtesy of Chapin DeAlba, 2003.)

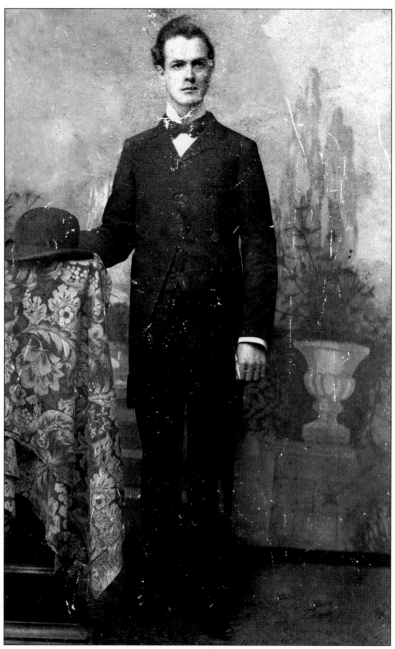

When William Taylor Chapin, shown above, arrived in Newport News about 1898, he worked in a real estate firm with J.L. Mayre and W. Scott Boyenton, The firm was incorporated in 1900, and Chapin's name appeared in the partnership. By 1935, the firm had become W.T. Chapin. Chapin's main interest was real estate, but the company also offered insurance. W.T. Chapin was very active in the developing community of Newport News. The firm's initial location was the Silsby's Building. However, the firm moved several more times in Mr. Chapin's lifetime. When he died at the age of 66, the offices were on 25th Street, which was then called the "Wall Street of Newport News." The walls, of course, were to come tumbling down. (Courtesy of the Chapin DeAlba Collection, *c.* 1902.)

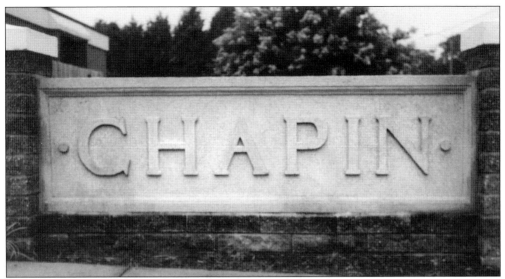

This stone marked the 25th Street office of Chapin. "When the building went down on 25th Street, I got the stone, and I took it up here [to the present site on Warwick Boulevard] and for a long time, it just lay on the grass. One day I said to myself, do something with that. So I had it set up, just as you see it there. It looks really nice, don't you think?"—Sam Waddill III, great-grandson of the founder. W.T. Chapin still survives, although primarily as an independent insurance agency, for the same reason many independent businesses in Newport News have—the family remains in control of the company. (Courtesy of Chapin DeAlba, 2003.)

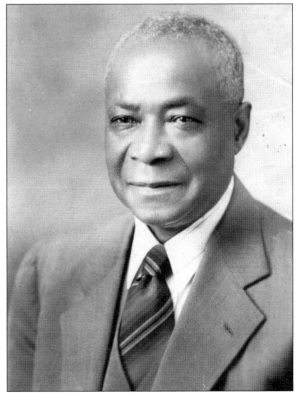

One of the most remarkable of the black leaders in early Newport News was Joseph Thomas Newsome. Born in Sussex County in 1869, he was the sixth of eight children. Newsome remained with his family on the Princeton Plantation and attended church school there. He grew frustrated by the primitive life in Sussex and the few opportunities open to him. When he was 22, he went to Petersburg to attend school in hopes of becoming a teacher. In Petersburg, politics and the law captured Newsome. He made his way to Howard University, and in 1898, he graduated as valedictorian. (Courtesy of the Newsome House Collection, c. 1930.)

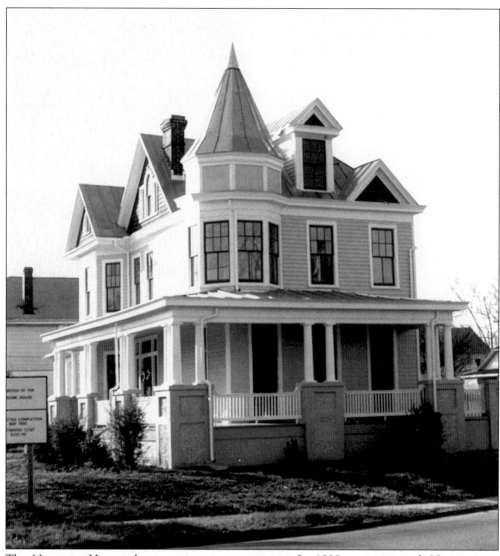

The Newsome House, shown as it exists at present. In 1899, marriage took Newsome to Newport News where his spectacular success enabled him to buy two lots, combine them, and build the fine Victorian house shown here. He was an excellent lawyer, respected for his speaking skills. His ability to motivate others and his courage in the face of increasing pressures from the Jim Crow laws were well respected. When he died in 1942, his funeral drew huge crowds. At Mrs. Newsome's death, their only grandchild sold the home to The Newsome House Foundation. Cornelius and Carrie Brown spearheaded the movement to restore the house and today, the house is on the National Register of Historic Places. (Courtesy of the Newsome House Collection, c. 1990.)

The original Royall optometry building is shown on the right with a special eyeglasses sign. (Courtesy Royall Family Collection, c. 1915)

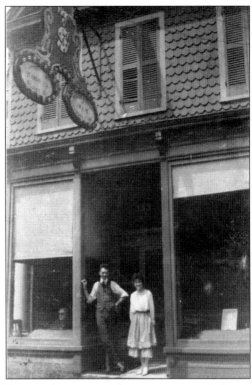

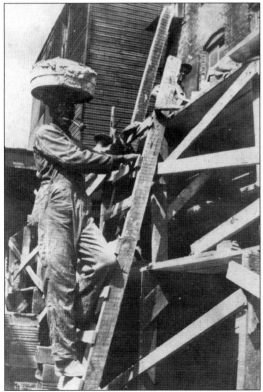

The picture shows a workman carrying concrete on his head up a ladder at the construction site of the Royall building. The concrete container looks like a hat. The building was brick, with brass plates across the front. Mary Lou Royall, granddaughter of the first Dr. Royall, said, "In the 1970s, when downtown started to fall apart, my dad sold the building. It was not torn down until 1997 or 1998 because it backed up to Woolworth's. Our building could not be removed until Woolworth's went. It turned out that Woolworth's was steel reinforced stone so it could be used as a fallout shelter. Three of us went down there every night, to watch — Daddy wouldn't go, but we did. The police and the construction people gave us the stone on top of the building and one of the brass plates. I put the stone in the yard, and the girls who cut the grass didn't want to go near it, because they thought maybe it was Daddy's tombstone!" (Courtesy of the Royall Family Collection, 1920.)

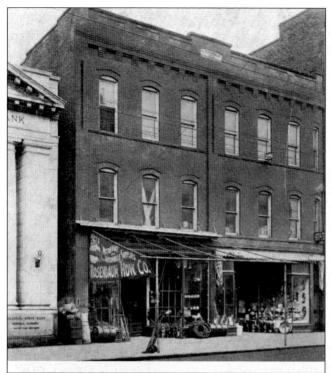

Adolph Rosenbaum, one of whose stores is shown here, arrived in the 1880s. He could hardly have imagined how much this new land would allow him to flourish. He came from London at the right time. He was a cooper and a tinsmith, trades essential to roofing and to the work at the Yard. In 1885, he opened a small tin shop, which rapidly expanded into hardware. In 1904, he bought two lots at 2608 and 2610 Washington Avenue, and here he built this three-story building for Rosenbaum Hardware. Rosenbaum was an upstanding citizen, pleasant to deal with, and a strong supporter of the Jewish community. (Courtesy of the Mays Collection, c. 1915.)

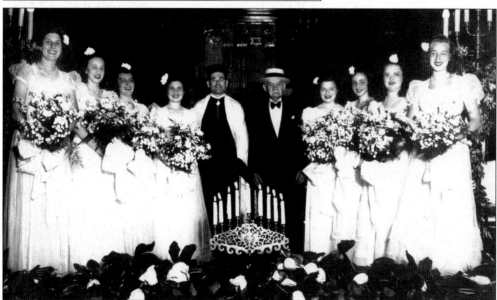

Rosenbaum, shown here with Rabbi Finkle of Adath Jerushun, collected antique ivory pieces, including an ivory chess set. He played chess with his grandson, Donald, and the experience lingered in the child's memory. As WWII was raging, Adolph died. His collection was broken up and sold. On a trip, Donald saw an ivory chess piece and realized it had belonged to his grandfather. It awakened in him the same passion his grandfather had felt. For the remainder of his life, he sought out antique ivories, almost as though he was trying to rebuild the chess set of his beloved grandfather. (Courtesy of the Jewish Historical Society, c. 1940.)

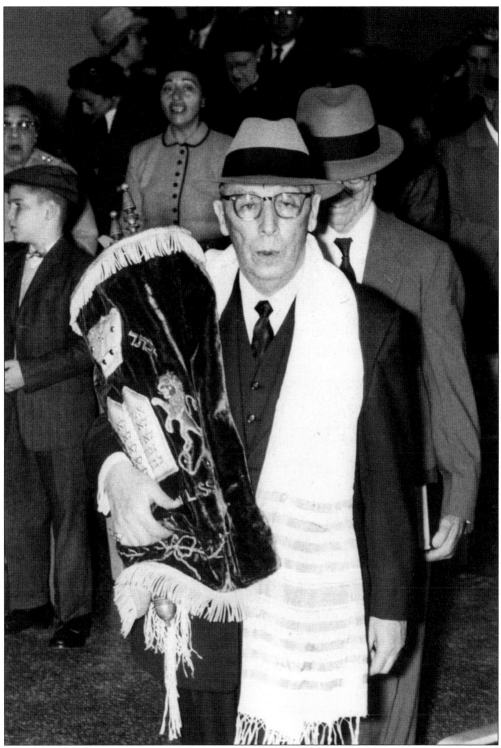

Harry Reyner, who became the first Jewish mayor of Newport News, is shown here carrying the Torah at the dedication of Rodef Sholom. (Courtesy of Jewish Historical Society.)

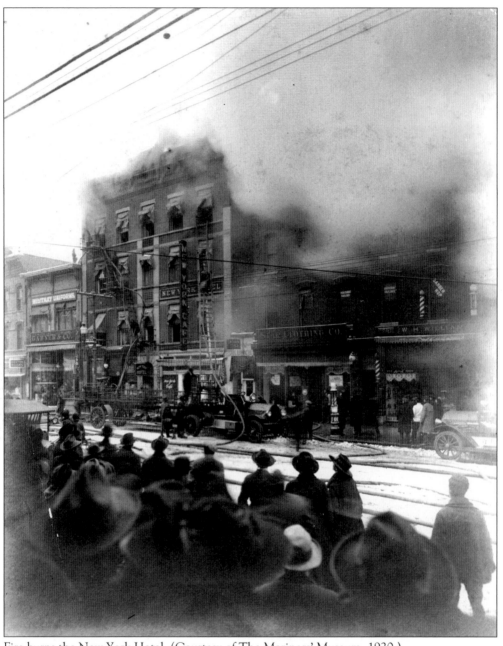

Fire burns the New York Hotel. (Courtesy of The Mariners' Museum, 1920.)

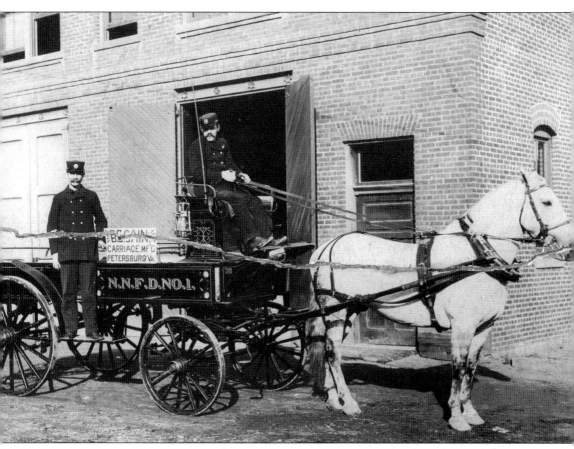

Fire!

This is the Newport News Fire Department in 1897—it had been organized in 1891 after a fire destroyed a full city block of 26 homes and businesses. Like many a new town, Newport News threw up buildings fairly hastily. During the early years of its history there were some spectacular fires. These fires revealed the importance of having a well-equipped fire department—not that the equipment in the first years of the 20th century was particularly advanced. The following pictures show the development of fire fighting over a 50-year span. (Courtesy of the Mays Collection.)

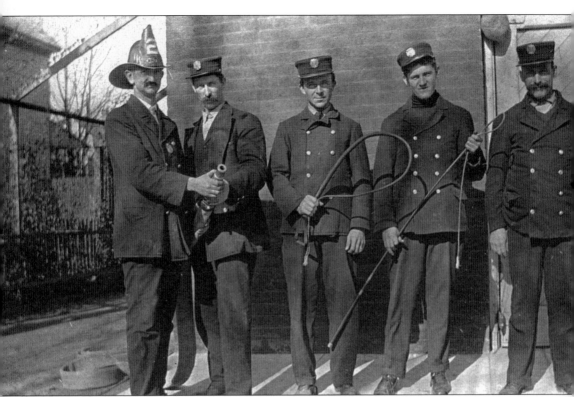

This photograph shows five local fire fighters in 1907. These five men made up more than half of the entire fire department at the time. The two men on the left are holding a nozzle connected to a canvas hose. Horses pulled the fire engines—one poor horse, Harry, "goes down and out," according to the fire department records, at a fire in 1906. (Courtesy of the Mays Collection, 1907.)

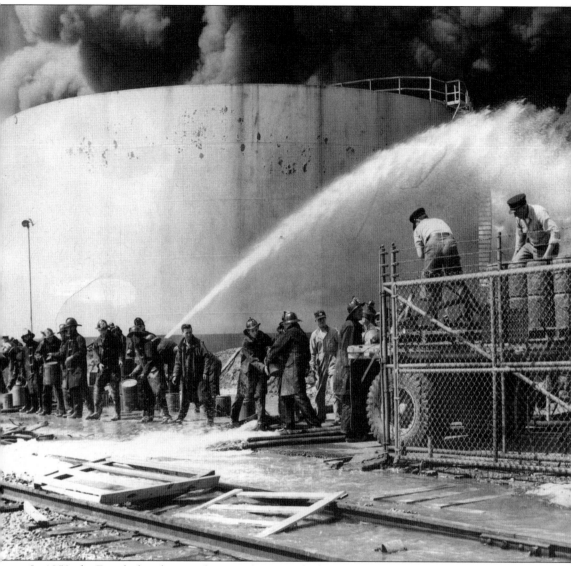

In 1958, the Esso fuel tanks near the waterfront caught fire and the blaze was spectacular, as one can see from this picture. Two current residents still remember that fire. "It was night, and I was in bed, when all of a sudden the sky lit up like it was day. I jumped out of bed and got my dad, and we could see the light in the sky. We began to run toward the fire—we ran and ran—and finally we realized it was all the way downtown, so we walked back home and went to bed."—F. Mays. "I was 19, and we had just come to Newport News. I was asleep, and it was the middle of the night, and the light came in my room. I looked out—I could see the fire just shooting up out of those tanks, like plumes. It was right by me. I thought, Oh, Lord, sweet Jesus—the world is coming to an end! That fire burned for three days. I think they had to bring in planes to put it out and they dropped something on it, like foam. I heard that someone was pouring some oil into something and it just blew up but I don't know that for sure."—F. Bowser. (Courtesy of the Mays Collection, 1958.)

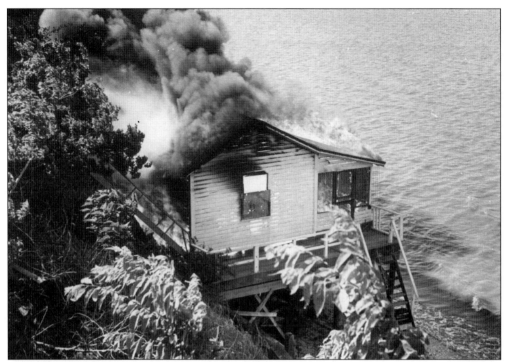

This little beach house on the James went up like tinder. Sometimes local families of English descent burn their Christmas trees. Perhaps this fire could have been a result of this tradition. (Courtesy of the Mays Collection, 1968.)

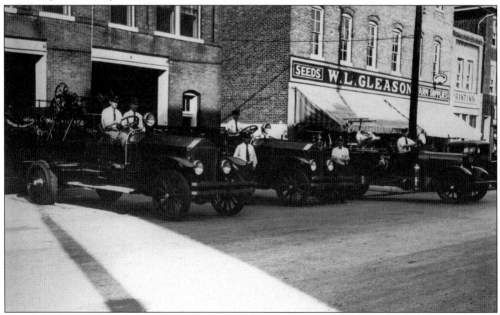

Men who undertake fire-fighting appear so casual, as they do here. They sit in the firehouse, playing cards, or showing little children the huge and shiny engines. When the alarm sounds and a fire burns, each man knows he must put his life at risk for the community. (Courtesy of the Hampton Roads Chamber of Commerce, c. 1930.)

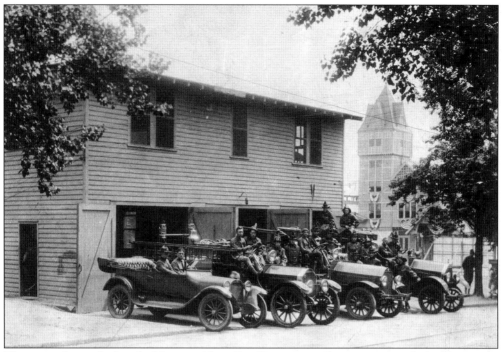

The men who worked at the Newport News Fire Department downtown pose for a photograph. How could they do their work in those days? With no particular gear to shelter their bodies or their lungs, these men don't appear worried as they wait for the alarm. (Courtesy of the Mays Collection, 1917.)

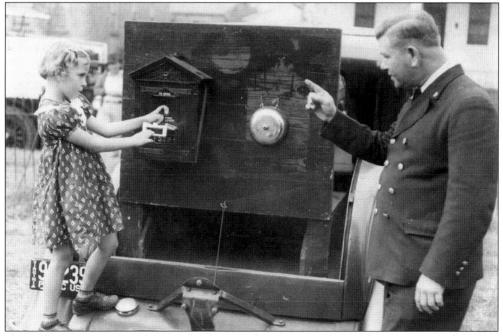

Shown here is Assistant Chief Garland Power demonstrating a fire alarm to Miss Nell Avery. He is showing her how to turn in an alarm. (Courtesy of the Mays Collection, c. 1950.)

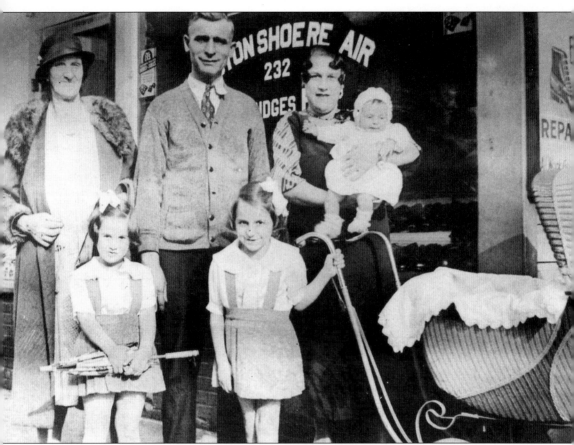

The Handges family poses in front of their shop. The adults, including a grandmother, arrived from Greece. (Courtesy of the Samos Collection, *c.* 1935.)

Three

BECOMING AMERICA

The early residents of Newport News were both blacks and whites. Both groups were strong believers in Christianity. The South is still considered the "Bible belt." Until quite recently, religion has provided a subtext for almost all of the residents of this community. Despite the influx of new people from diverse cultural backgrounds, religion still remains a focal point for many people in the community today.

Newport News' first church was built by a black Baptist congregation in 1864, one year before the end of the Civil War. The location of the church today would be 28th Street, and where it stood, railroad tracks now lie. The building, although not elegant, seated 500 people and drew large crowds. The church was named the First Baptist Church of Newport News.

In 1897, as Newport News was developing, the church moved to 24th Street and the congregation undertook the construction of a new, brick building. The new church was truly magnificent and was distinguished by a tall steeple that towered over the surrounding churches, as the picture on the next page shows. In 1946, the church was still active, with a membership of 1,500 people. At this point, the steeple had begun to decay and had to be removed. With the arrival of so many new people to the area, the church lost members to newer congregations. A number of Baptist churches now serve the downtown, largely African-American, congregations.

Far from the city was a small enclave called Gum Grove, so named because of the large number of gum trees that grew in the area. Once the Civil War ended, black families slowly moved away from the farms on which they had been slaves, and some of these families settled in Gum Grove. They built a small, simple wooden church on the present site of Warwick High School. The church was probably called First Baptist. The graveyard, located about a mile from the church, still remains today.

Once the C&O came to town, many small railroad stations were built. One station was at Gum Grove. In honor of J.S. Morrison, who oversaw the laying of the railroad tracks from Lee Hall to Newport News, the C&O named the station Morrison. The community soon took this name. First Baptist Morrison was eventually moved because of construction for Warwick High. The church was picked up and placed on the west side of Warwick Boulevard. This location was much closer to the cemetery than the previous site.

When Christopher Newport University began the transformation into a residential school, First Baptist Morrison was again obliged to move. This time, however, sufficient funding permitted a large, handsome structure near the airport. When demolition of First Baptist Morrison began in 2003 on the site taken over by Christopher Newport, the congregation discovered that beneath the brick shell were two sets of framing, from two versions of the old church.

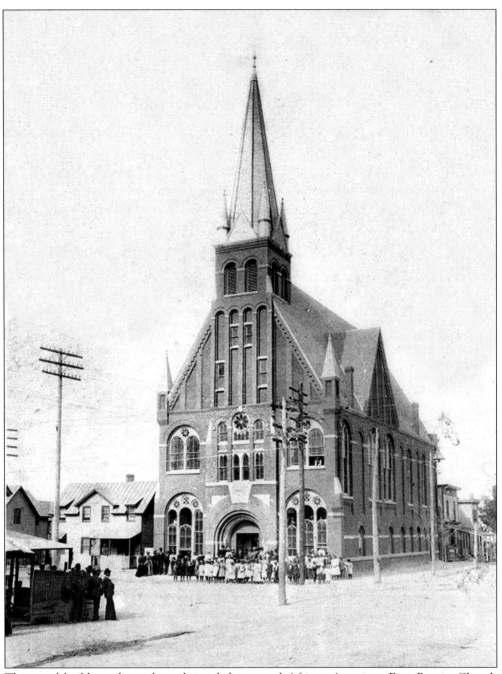

The grand building, shown here, housed the second African-American First Baptist Church that was the first of all the churches in Newport News. (Courtesy of First Street Baptist Church, c. 1910.)

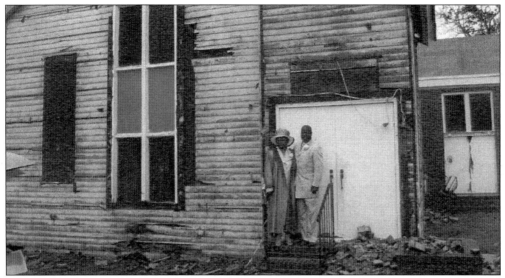

Marcellus Harris, Pastor, and his wife stand in front of the old First Baptist Morrison Church as all three layers are displayed. According to Reverend Harris, "When I came to First Baptist Morrison the congregation had voted to be an every Sunday church. You see, there had been a split. On the 1st and 3rd Sundays, people came to Morrison; on the 2nd and 4th, they went to Denbigh. My first day in the pulpit, the church was packed. I thought, All right! Yes, Lord! Then came the next Sunday. There was almost nobody there. Although they said they would come, they just kept to their old ways! I had to work hard to get a stable congregation." (Courtesy of Reverend Harris, 2003.)

John Bowser started in this storefront church downtown. "When we came here, we met Holtzclaw and he baptized John. Six months after, John preached his first sermon. We shared the storefront church, and then we bought it. As soon as he could, John knocked that storefront down. He took an axe to it. He put the sanctuary upstairs. Mr. Wilkerson, he said, 'John, one day you are going to be old. You won't want to walk up all those stairs.' Mr. Wilkerson was right. It's hard to get those bodies up those stairs."—F. Bowser. (Courtesy of the Bowser Collection, c. 1960.)

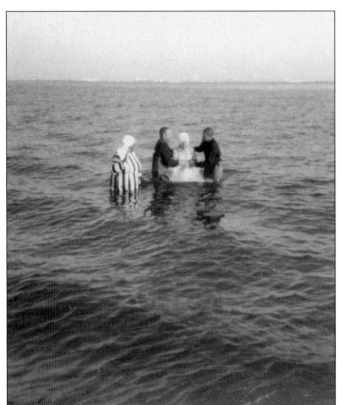

In many of the Baptist churches, the practice of baptism by immersion took place in rivers, as is the one taking place here. Since the James River is very shallow in places, it was simple to walk out pretty far into the river and to conduct a baptism. Many people wanted to be baptized in the river water because they felt that they were emulating Jesus when they did so. (Courtesy of the Bowser Collection, *c.* 1970.)

A new church is shown under construction in this photograph. This is the church that John Bowser, his congregation, and his family built on the site of the old storefront church. (Courtesy of the Bowser Collection, *c.* 1970.)

Shown here is John Bowser, now the Bishop of the Most Glorious Church of Jesus Christ, when he first began his ministry. (Courtesy of the Bowser Collection, c.1950.)

Pictured here is Mother Frances Bowser, wife and devoted partner to John. (Courtesy of the Bowser Collection, c. 1950.)

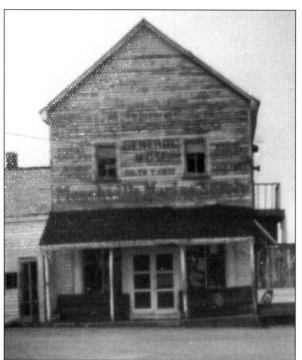

This historic store, Mench's, once lay at the foot of Menchville Road, on Deep Creek. It served both watermen and the Mennonite community. Many people still think Hudson Mench was a Mennonite, but it was just a coincidence that he arrived at the same time the devoutly religious and hard-working Mennonites established a religious community in the area of the Warwick River and Lucas Creek Road. The Mennonites created a different culture. While many of their descendants still live in the area, almost none now pursue their once-chosen vocations of farming and fishing. (Courtesy Proffit family Collection, *c.* 1920.)

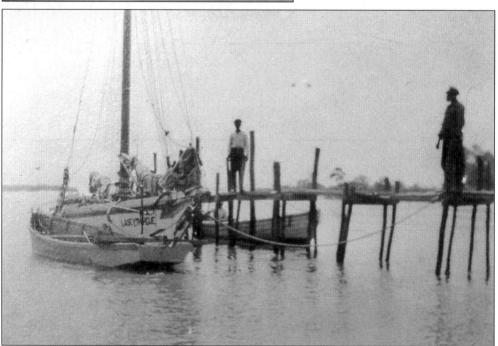

Shown here is a picture of an old boat at the Menchville dock. After the Mench family sold the business, the Peroks bought it and tried to keep the oyster business going. However, nearly all the commercial fishing and oystering activity has stopped. The local Virginia seafood business is no longer thriving, and the area around the site of the old Mench store is in the process of becoming gentrified. (Courtesy of the Proffit Collection, *c.* 1920.)

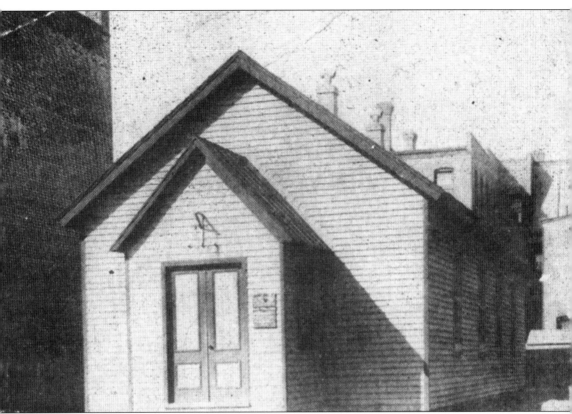

In 1882, the Old Dominion Land Company built Union Chapel, shown here. It was a simple frame structure to be shared by all white Protestant denominations. This arrangement only lasted for a year. The Baptists were the first to build their own church. Over the next decade, numerous denominations prospered and built their own churches. Not everyone who moved into the new town was motivated by strong religious or moral codes. Two lawless sections were present in the 1880s. "Hell's Half Acre" was one of the rough areas, and a murder occurred there about once a week. Few tales can top that of the criminal who, in a rage at being thrown in jail, took out a match and set fire to the building. The first City Jail was reduced to a pile of ashes and so was the man who set the blaze. (Photograph by Griffith, c. 1900.)

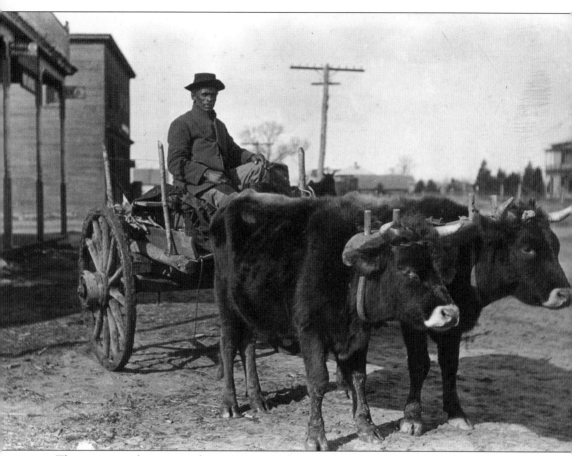

The ox cart above was the 1900 equivalent of a taxi in early Newport News. Public transportation took several years to be set in place, since the streetcars that would serve the town depended on electric power. There were no cars, and the roads were unpaved and muddy. Ladies coped with long skirts dragging in the mud, and early accounts describe women crossing overgrown fields to get to meetings. The transportation difficulties played a major role in the rapidity with which the denominations established mission churches, so people could easily get to church. The mission churches were important, also, to the spread and influence of the denominations. While the first generation of church buildings was fairly simple, the second—as the next two pictures show—were handsome structures, most of which still stand.

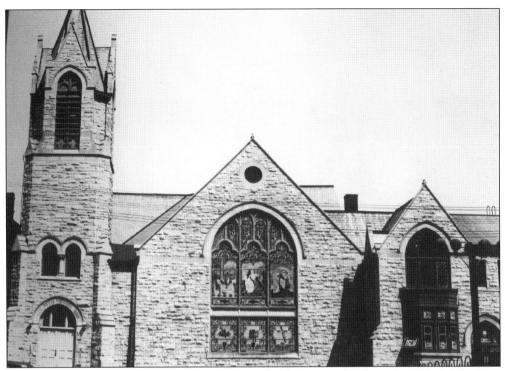

Like its age-related peers, First Presbyterian Church was quite grand. Most of these churches still stand today. In 1956, life would change for residents of the area as downtown began urban renewal, and activity—residential and commercial—moved uptown. The downtown population would shrink even further by the 1970s. (Hampton Roads Chamber of Commerce, *c.* 1930.)

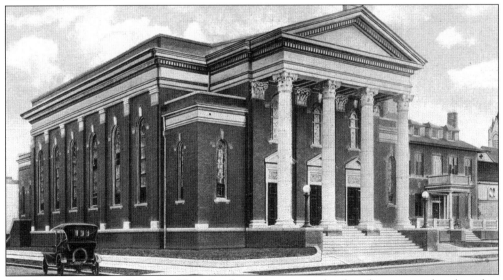

St. Vincent's Roman Catholic Church, above, is among the few downtown churches that remain in the hands of the original congregation. Other churches were not as lucky and were forced to move by the continuing migration of residents northward and the aging of the remaining worshipers. (Courtesy Cones Collection.)

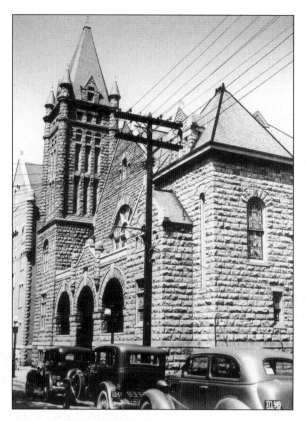

First Baptist Church for whites is shown here. Like the Christians, Jewish families came from a deeply religious background. It was not long before they began to look for a way to satisfy their religious hunger. Arriving in the late 1880s, Abraham Mirmelstein was the town's first Rabbi, and religious services were held in private homes. Adolph Rosenbaum pushed for the group to build a synagogue. The small Jewish community's response was exceptionally generous, and in 1893, the orthodox synagogue Adath Jeshurun was established on 23rd Street and Washington Avenue. Later, Adath Jeshurun moved to Madison Avenue and 23rd Street. By the end of the century, a new and modern building housed the synagogue at the northern end of Newport News, on Nettles Drive. (Courtesy Hampton Roads Chamber of Commerce.)

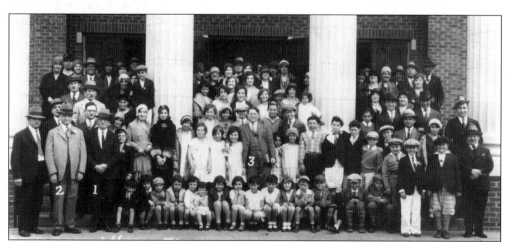

Adath Jeshurun, above, was and remains an orthodox synagogue. A conservative Jewish congregation established a second synagogue, Rodef Sholom, in 1913. Temple Sinai, a Reformed congregation, was founded in 1955. In the early days of Newport News's development, while people were aware of religious differences and marriages between religious groups were not common, older members of the Jewish community say that they felt no exclusion. These early citizens made, and their descendants continue to make, important contributions to the quality of life in the area. (Courtesy Jewish Historical Society, c. 1930).

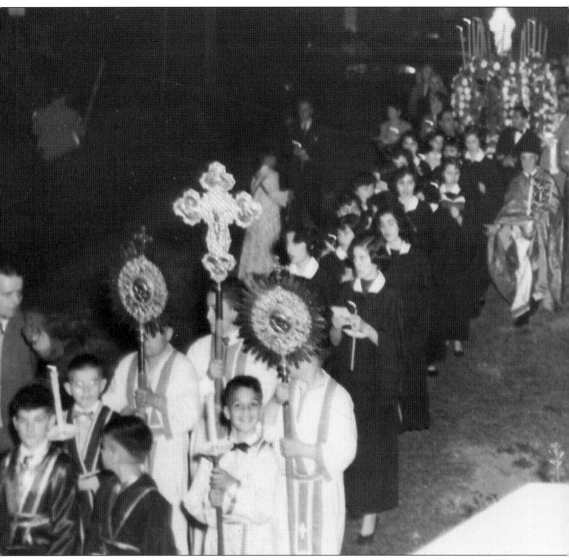

The Greeks, shown here in an Epiphany celebration, at first came in very small numbers. They were drawn here because of the area's proximity to the water. Some of the ships coming into the port of Newport News carried Greek seamen. Many of these men took news back to Greece of an area that might offer opportunities. Immigrants from Greece began to trickle in to Newport News before the beginning of the 20th century. It was not until after WWI that they established themselves as a community of faith. In 1934, they formed the Hellenic Educational Society. They started a Greek School, a typical endeavor of Greeks wishing to preserve their heritage, and a community board. Initially, they worshipped at St. Paul's Episcopal Church by invitation. Often visiting Greek Orthodox priests conducted services at St. Paul's for them.

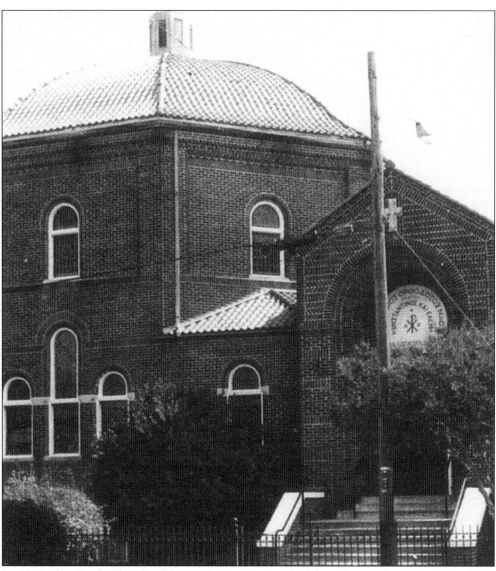

In 1949, the Greek Church of Saints Constantine and Helen, shown above, was completed downtown. The congregation numbered only 50 families, but their vigor and religious dedication was evident. Their decision to build a Community Center in 1966 led to the rise of an annual festival. It was this gathering that brought their community to the attention of everyone in Newport News. The feast of Greek food and wine attracted many non-Greeks. People came in such great numbers that the Hellenic Festival, as it is now called, was a must-attend for local politicians. "When we moved here, the kids were little and we were always looking for things to do. We saw the signs—I think it was called the Greek Bazaar in those days—and we all went. It was wonderful. They loved it and we did too—our little one kept asking when we could go next to the 'Bazeek Gabar!' The Festival bonds all of us together in just a fantastic way."—J. Carter. (Photo Courtesy Samos Collection.)

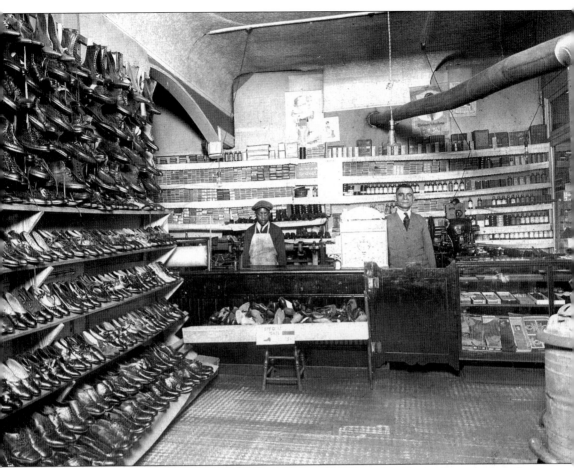

The Boston Shoe Repair Shop, shown here, was owned by Harry Handges, who immigrated from Greece. Like most new residents, the Greeks settled in the downtown area. "My father came here in 1910. He apprenticed himself to a shoe repairman in Hampton, and once he got the hang of it, he opened a shoe store on 25th Street. It was a good business, very different from today. He sold new shoes, and he sold used shoes. He repaired shoes, too. The Boston Shoe Repair Shop didn't have anything to do with Boston. It was a great location. We got the white people walking up and down, and the black people because they had to cross over the 25th Street Bridge to get home."—A. Samos. (Photo Courtesy of the Samos Collection, c. 1920.)

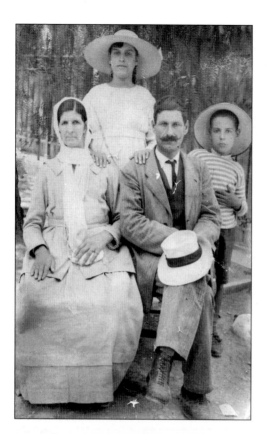

Shown in this photograph are Agnes Handges's mother and grandmother, preparing to travel to America. (Courtesy of the Samos Collection, *c.* 1930.)

This photograph captures Agnes's mother in the car and her father, Harry Handges, during their courtship. Mr. Handges went to New York to buy goods. He always bought new and used shoes, but once WWII began, he bought many more used shoes. New leather shoes were rationed but used ones were not. Work for shoe repairers was in high demand during the war years. (Courtesy of the Samos Collection, *c.* 1930.)

Agnes Handges is standing in front of the Boston Repair Shop. Once the war was over, the Handges family began to buy property nearby. By the mid-1950s, Harry Handges owned several lots, including the American Restaurant location. Working hard and doing well, he had lived the American Dream. However, when urban renewal took over the area, all of his properties were condemned. "My father went to see our building knocked down. But when the wrecking ball hit, he dropped dead of a heart attack. It was a terrible time, terrible."—A. Samos. The collapse of downtown caused the Greek community to abandon their first church. In August of 1982, the last service was held there. (Courtesy Samos Collection, 1982.)

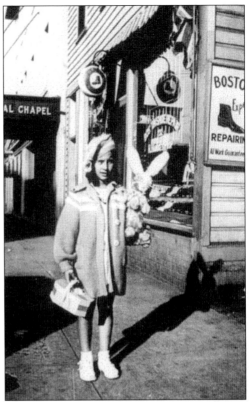

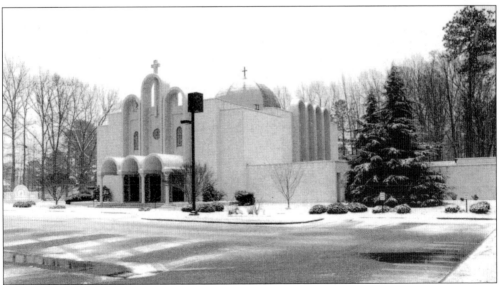

The magnificent Basilica of Saints Constantine and Helen Church was completed in 1982 and consecrated in 1984. As time passed, change came to the Greek community. Once, young women rarely married out of their ethnic group. Now, young people move between two worlds. The Greek school started so long ago continues. Greek businessmen in Newport News have made their mark in their adopted community. The Hellenic Festival unites Newport News with wonderful food, good company, and friends. (Courtesy of the Samos Collection, c. 1995.)

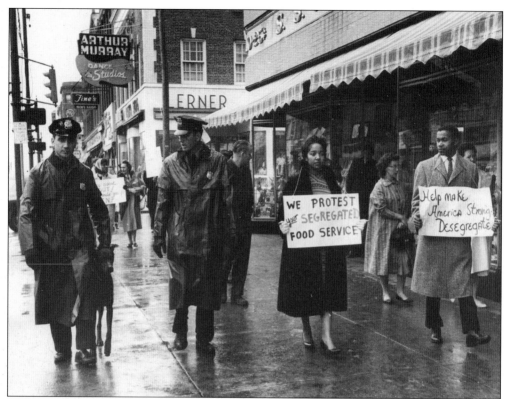

At last, the demands from the black community for equal rights came in the early 1960s. Quiet for so long, the African Americans who had fought in the wars, died for their country, and whose expectations had been set by *Brown v. Board of Education*, began to raise their voices. In Newport News, the terrible ripping of the social fabric that took place in other parts of the South did not occur. Slowly, but with an inevitable force, black men and women drove America to live up to the promises made in the Declaration of Independence. (Courtesy of the Mays Collection, 1963.)

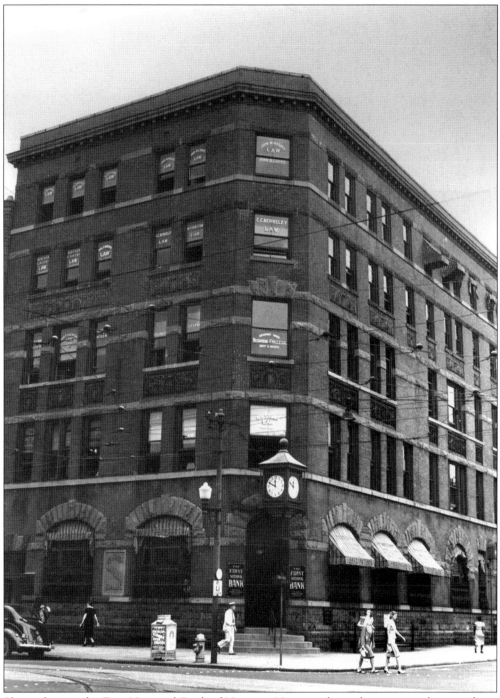

Shown here is the First National Bank of Newport News, a place where many white residents conducted business. (Courtesy of the Hampton Roads Chamber of Commerce, c. 1930.)

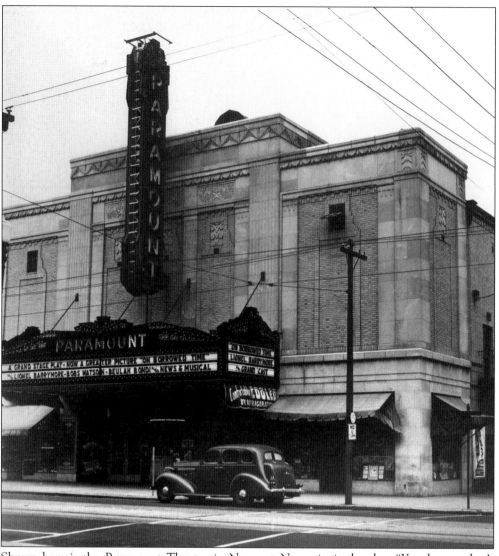

Shown here is the Paramount Theatre in Newport News, in its heyday. "You know what's wrong here? They let the downtown die—really, I think they killed it. Then they just turned their back on it and moved on up. The first mall—that was the beginning of the end. Then that mall died, and they turned their backs and moved on up again. What are they going to do when they bump into Williamsburg? By that time, everything will be dead."—D. Lee. (Courtesy of the Hampton Roads Chamber of Commerce, *c.* 1930.)

LAND OF THE LIFE WORTH LIVING

Baseball collector Donnie Lee, shown at top right, says, "This used to be the best place in the world to live. I'm telling you. We had such fun. Everyone went to the movies—the Paramount was the best; it was really grand. You'd leave the Paramount, and then you'd go past these stores, and the only place you could buy baseball cards was in this place they sold beer. And we'd go in there, and the guy would say, 'What you boys doing here?' sort of rough, you know, and we'd say we were just there for the baseball cards. So he would let us hang out until we found what we wanted. I just loved those cards. I still do."

A treasure from the past, one of Donnie Lee's baseball cards, is shown at right below. (Courtesy of the Lee Collection, 1982.)

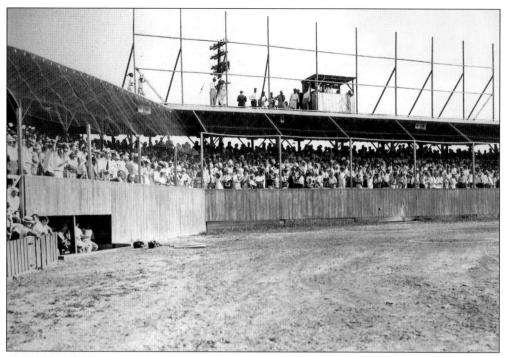

Builders Ball Park was a favorite place for young and old to gather in the summer. (Courtesy Hampton Roads Chamber of Commerce, c. 1930.)

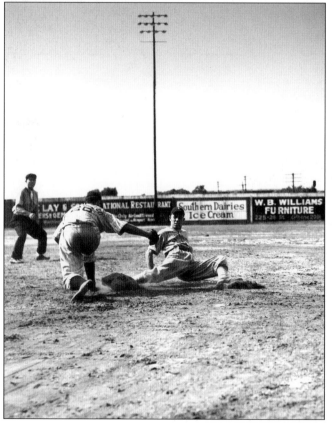

A player slides into the base in a close play at Builders Ball Park. Notice the signs for local businesses that are displayed on the outfield fence. (Courtesy Hampton Roads Chamber of Commerce, c. 1930.)

This Sunfish, shown on the right, is being towed out of the marsh. "I used to sit and watch the kids sail at the Warwick Yacht Club [in Deep Creek]. You never heard such hollering, some days. The wind would come up, and over they'd go. Sometimes NO wind and over they'd go—I guess they got hot out there. Then a kid would get in irons and his boat would just drift into the marsh grass, everyone yelling at him to pull in his sheet [rope]. I would just about split my sides laughing. I hear they got good enough to whip the kids all up the Bay, however." —Percy Keffer. (Courtesy of the Webb Collection, c. 1980.)

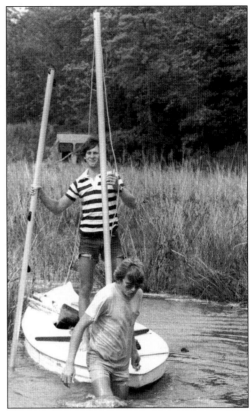

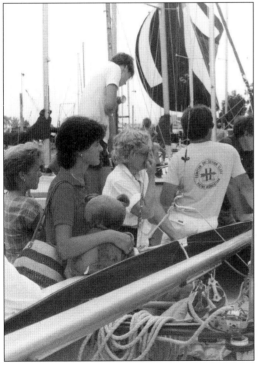

This group of young Newport News sailors on the left is watching their peers at a regatta at the Hampton Yacht Club that will test their skills against teams from the Southern Bay. (Courtesy of the Webb Collection, 1975.)

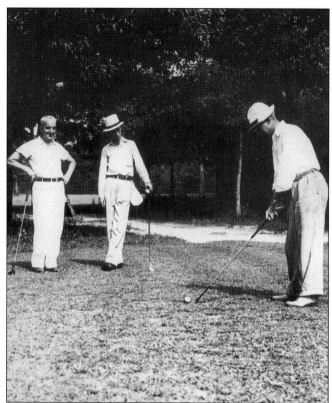

Golfers are shown here at play at the James River Country Club. "Some people like to sail, some people like to hunt—I like to play golf." —B. Hutchens. Archer Huntington had a collection of antique golf clubs. He said if the club would acquire them and build on a wing for a golf museum, he would pay for the wing. Needless to say, the wing was built. (Courtesy Hampton Roads Chamber of Commerce, c. 1930.)

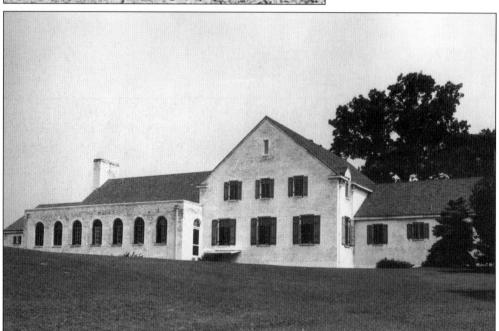

The James River Country Club—which has an excellent dining facility in addition to a swimming pools, tennis courts, and golf course—is shown shortly after it was built. (Courtesy of The Hampton Roads Chamber of Commerce, c. 1930.)

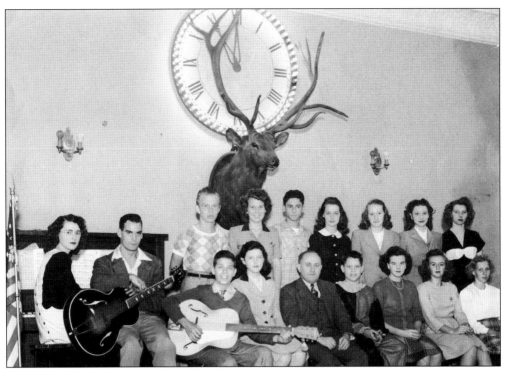

The young people in the Elks Club Players gather to practice. "When the troops came, Gladys [Lyle, the organist at the Paramount] organized us into a variety troop. The Elks Club sponsored us, and we would perform for the troops. They clapped and clapped AND CLAPPED. I guess they were so lonely." —S. Coleman. (Photograph by Griffith, Courtesy Schult Collection, 1943.)

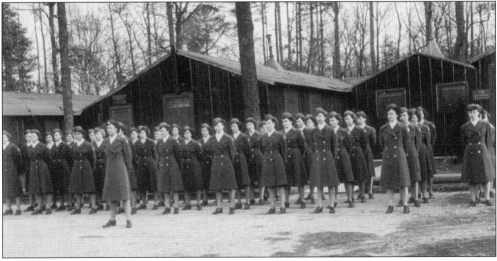

The 3rd WAC Company is seen at parade rest in Newport News. "Nowadays when everyone can do everything, it's difficult for today's young people to understand how different things were for my generation. We didn't go into combat, though. We marched and so on—but we did the desk work so the men could go off and fight." —M.H. Parker. (Courtesy of Library of Virginia, c. 1940.)

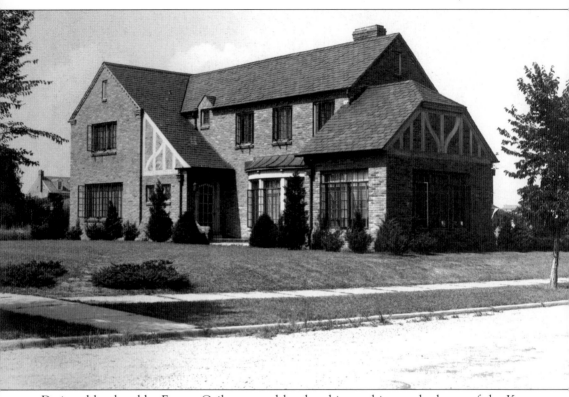

Designed by the elder Forrest Coile, a noted local architect, this was the home of the Kates family. Rena Nachman Kates was the daughter of the Nachmans, and here the Kates twins grew up. This family has always been generous and active in the community. (Courtesy of the Hampton Roads Chamber of Commerce, *c.* 1930.)

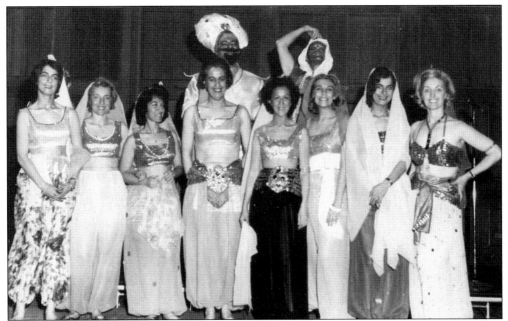

"We used to have such a lot of fun. This is the candlelight ball—for our synagogue, Rodef Sholom. I don't know remember who the guys at the back are—they were just cutups!" —J. Zilber. Shown in this picture (from left to right) are Sue Anne Kates Bangel, two unidentified people, Barbara Drucker Smith, Joanne Kates Roos, unidentified, and Lee Kahn Goldfarb. (Courtesy of the Jewish Historical Society, c. 1955.)

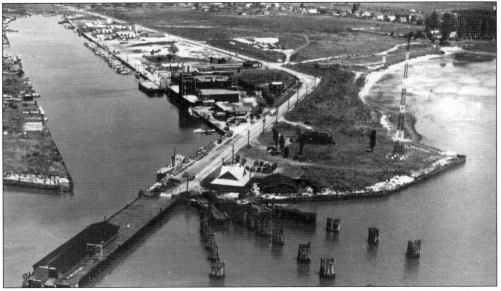

Pinkett's Beach, now part of King-Lincoln Park, is to the right in this picture of the Small Boat Harbor. Sweet Daddy Grace would baptize people there. "My sister—she got all caught up, she thought Sweet Daddy Grace was so wonderful. Sweet Daddy used to ride in a parade with pretty girls in white just fanning him, and he would wave those long fingernails all painted red white and blue. He would kiss a Co' Cola bottle you could buy for a nickel, and then those folks would buy it for a dollar!" —F. Bowser. (Hampton Roads Chamber of Commerce, c. 1930.)

Princess Bonita, shown here, describes her time in Newport News. "I graduated from Newport News High School, and I went to work for Langley. Hampton held the National Seafood Festival, and they asked me to be in it. So I agreed. The dress I wore in the festival—with all the fish on it—was so heavy they had to lift me onto the float! I was 19 at the time." (Courtesy of Princess Bonita, Private Collection, c. 1950.)

Nachman's Department Store, downtown, was a favorite shopping place. "Everyone was worried when Sol [Mr. Nachman] died, about 1928. Mrs. Nachman said to the lawyers, 'I understand the store, but I do not understand these stocks. Get rid of them.' The lawyers said, 'Mrs. Nachman, that's foolish—the stock market is booming, and you will just be throwing your money away!' But they did sell some things, and of course the stock market crashed and she had plenty of money. She was wonderfully generous—everyone was so poor." —E. Drucker. One of Mrs. Nachman's granddaughters said that her grandmother was on her hands and knees unpacking boxes to go in the new store (above), and a friend said, "Ida, you do not have to do that!" Ida Nachman said, "You don't understand. My children will need work." —S. Bangel. (Hampton Roads Chamber of Commerce, c. 1930.)

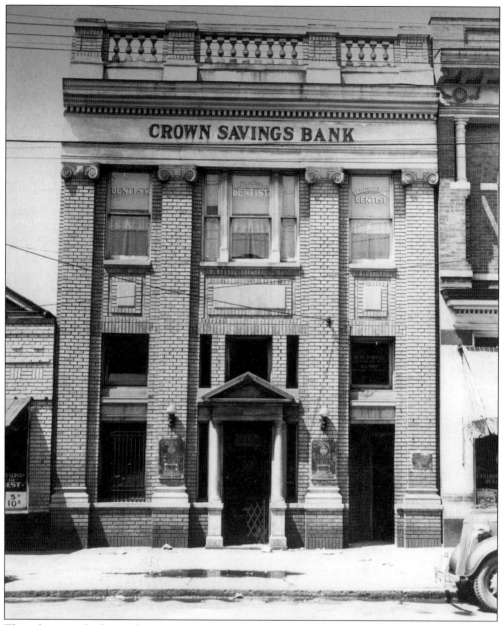

This photograph shows the Crown Savings Bank established by and for African Americans. Unlike most of the white-run banks, the Board included women. Through a series of mergers and acquisitions by larger banking systems, what was then Crown is now a part of Wachovia. (Hampton Roads Chamber of Commerce, c. 1930.)

Four

HOW DOES YOUR BUSINESS GROW?

With Plenty of Pluck and a Little Luck and Customers all in a Row . . .
 Looking over the history of businesses in this area, it is clear that the (somewhat altered) nursery rhyme above is true. Hard work is usually essential, at least in the early days of a business. A strong intuition, good sales instincts, a willingness to keep putting money back in the business rather than choosing to live the high life are factors of success. Luck is another factor. Some companies in Newport News have failed because they had bad luck. The businesses that did not pull out of the downtown at the right time, or did not amass a sufficient amount of capital shut down. The businesses described in this chapter have all succeeded.

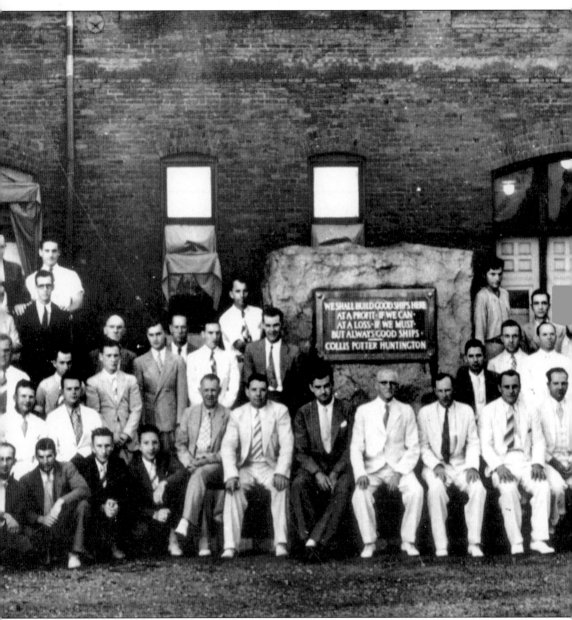

A group of Shipyard workers pose around the famous sign bearing Collis P. Huntington's words: "We shall build good ships here; at a profit if we can, at a loss if we must, but always good ships." Homer Ferguson became the president of the shipyard by a twist of fate—the incumbent, A.L. Hopkins, died in the sinking of the *Lusitania*. However, Ferguson had the perfect background and temperament to run the Yard. A graduate of the Naval Academy, he held a masters degree in Naval Architecture. He was a hands-on manager who had the reputation of knowing every worker and every ship. He was so good at his job that, when Archer Huntington started The Mariners' Museum, Huntington insisted Ferguson run the museum also. (Courtesy the A. C. Brown Collection, *c*. 1935.)

The Yard was a great success for Homer Ferguson. His son, Charles, seen on the left in this excerpt from a famous family photo, decided to march to the beat of a different drum. He started out working for Noland, where he learned the plumbing business. However, Lloyd Noland was a hard man. Charlie Ferguson was an aggressive man with his own ideas. At some point, there was a clash. Opinions differ about what happened next. It is enough to know that Charlie Ferguson started his own business in competition with his former employer. Ferguson Enterprises is the empire that the son built, and it is a testimony to the family ability. Charlie Ferguson could pick key employees well. One of his early colleagues was David Peebles, who not only had experience in the business but also had an ability to build consensus that enabled the ever-larger company to pull together. As was the case with the Shipyard, which eventually became a publicly traded company no longer locally owned, Ferguson Enterprises is now a subsidiary of a much larger group. (Courtesy of Newport News Shipbuilding, 1918.)

Louis Drucker and his family are shown in Switzerland, where he had gone on the advice of his doctors to recover his health. Drucker came here from London in 1913. He was 17—his mother sent him away because she could see war coming: she had German relatives, and she didn't want members of her family fighting each other. (Courtesy of the Drucker Collection, 1933.)

This is the first Drucker and Falk building. "Dad [Louis Drucker] went into the grocery business. One day he went into the meat locker to check the inventory. He froze a lung, and contracted pleurisy, and he was sick for a long, long time. Fortunately, he had taken out insurance to cover his pre-1929 salary. We went to Switzerland so he could be at a high altitude with dry air, and then America went off the gold standard. You couldn't even bail your suit out of the cleaners with American money. So Mother took us home. When Dad finally came home, someone said, 'You should sell insurance—you are the perfect example why people should have it.' Then Manny Falk said that real estate and insurance made a good match, so they set up a business. That's how it began." —E. Drucker. (Courtesy of the Drucker Collection, c. 1960.)

Shown here is the present-day Drucker and Falk building. "One secret to Drucker and Falk is partly that the family is still involved. Wendy Drucker and Kellie Falk-Tillett are the third generation and they are going strong. Manny's son David is very active, and his son David junior is coming along." —R. Huskey. (Courtesy of Drucker and Falk, c. 1990.)

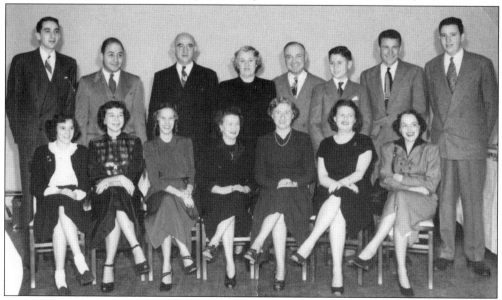

This family photograph of the Druckers, the Falks, and some staff was taken in 1948. (Courtesy of Drucker and Falk, 1948.)

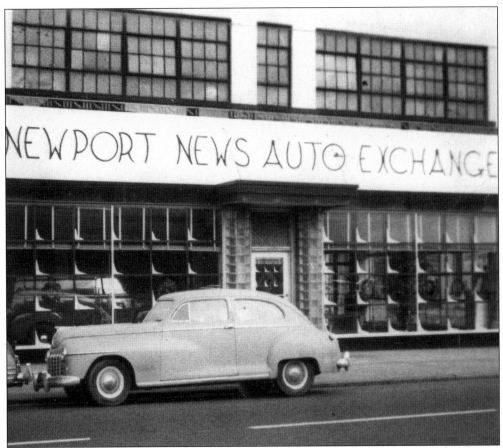

Charles K. Hutchens and John Watkins started the Newport News Automobile Exchange, shown above, in 1921. The two began selling used cars, and The Exchange was so successful that the partners were able to choose Chevrolet as their company of choice. (Courtesy of the Hutchens Family Collection, *c.* 1940.)

New cars required a major remodeling of the building. In 1931, John Watkins died and the Depression had begun, but Charles Hutchens believed in the future. He added to his property twice before the war began. (Courtesy of the Hutchens Family Collection, c. 1932.)

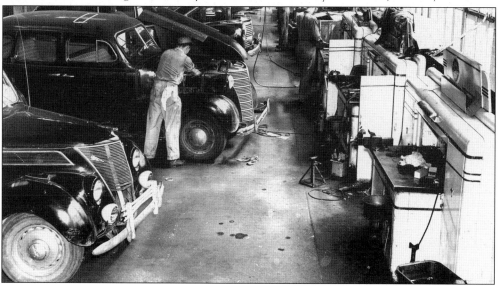

Hutchens' investment in repair equipment, above, was to serve Newport News well during the war. While his people strove to keep cars running, the War Price and Ration Board occupied the showroom. But the 1950s condemnation did not spare Hutchens. "Those were scary times. It was really nip and tuck whether we would survive. But when we moved, we went the right way—north, way north. We kept our reputation and our customers, though, and almost 50 years later, here we are, doing fine." —B. Hutchens. (Courtesy of the Hutchens Family Collection, 1938.)

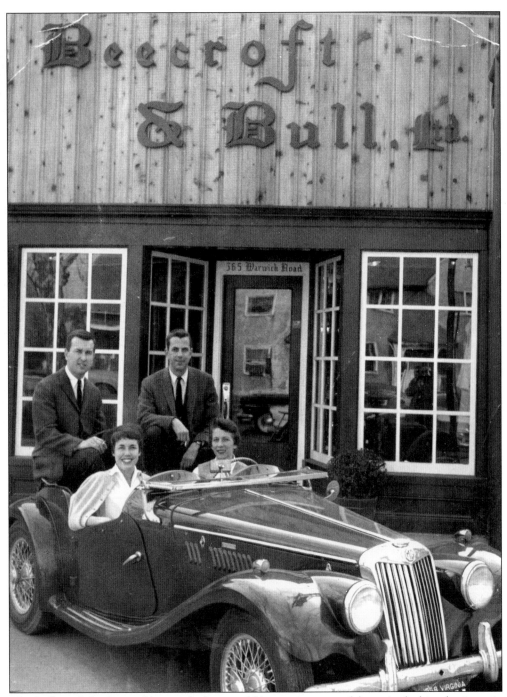

The Bulls and the Beecrofts started what would be a very successful men's clothing business in Hilton Village, in the store shown behind the two couples, in 1959. Although the name remains, the partnership between the Bulls and the Beecrofts dissolved in short order. The Beecrofts bought out the Bulls in 1961. After the Bulls left, Frances Beecroft was the nuts and bolts person, and Moss set the style direction for the store. Moss Beecroft stuck with high quality, conservatively tailored men's clothing. In those days, that was not easy to find.

72

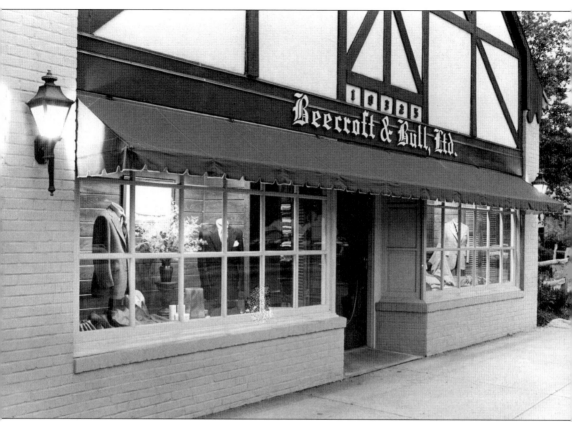

Pictured here is the present Beecroft and Bull Store in Hilton Village, which is now the parent store. "I can remember thinking, what am I doing, driving all the way from Norfolk to Newport News? But it was the only place I could find something I would put on my back. I'm a banker. Who wants to do business with a banker who has long hair and the kinds of clothes everybody was selling then? One day I said to Moss, 'Why don't you try coming to Norfolk—or even the Beach?' And eventually, they came." —C. Weaver, Norfolk. As the Beecrofts expanded, their sons came into the business. The boys proved to be as good as their parents. With the stores running smoothly, both Beecrofts could indulge in a hobby they shared—golf. In 2002, George Whalen's Online Newsletter, a retail specific publication, said of Beecroft and Bull, " . . . a terrific menswear store in downtown Norfolk. [T]his retailer sells both casual apparel as well as suits offering a great selection . . . and they are masters at making every customer feel important and appreciated . . . exceptional service . . . brings customers back again and again." (Photo Courtesy of the Beecroft Family, 1978.)

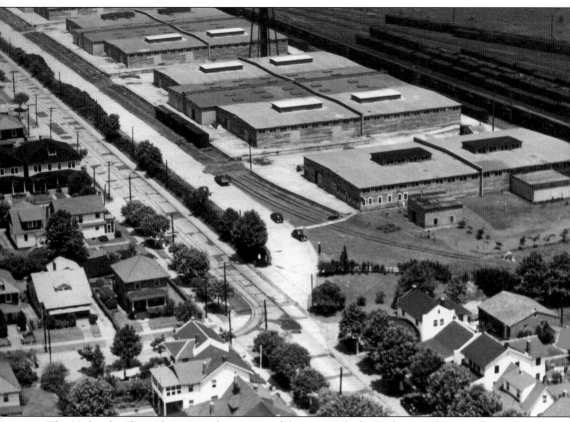

The Hiden family made its initial step toward fortune with the Hiden warehouses, shown here. These massive storage facilities are now located on Warwick Boulevard adjacent to the C&O train tracks. P.W. Hiden owned stockyards during WWI and was an extensive exporter of horses. In 1915 he had three warehouses located on 18th Street, 34th Street, and Elevator Hill. At the same time, he was a wholesale dealer in hay, grain, wood, and railroad ties. (Courtesy of the Hampton Roads Chamber of Commerce, c. 1930.)

This somewhat battered wooden horse at the corner of Warwick Boulevard and Shoe Lane advertised horse rentals on Briar Patch farm. When one of these horses died on a public street, neighboring residents were less than pleased. Warwick County refused to remove the deceased animal. So the residents, identities unrecorded, took matters into their own hands. When County Manager J. Clyde Morris woke the next morning, that horse, with an advanced case of rigor mortis, was right there on Mr. Morris's front lawn. (Photograph by A.C. Brown, courtesy of the Webb Collection.)

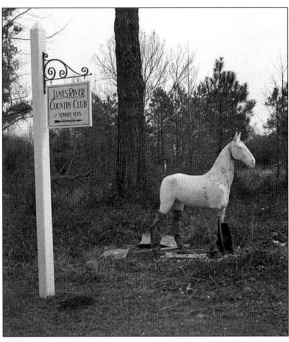

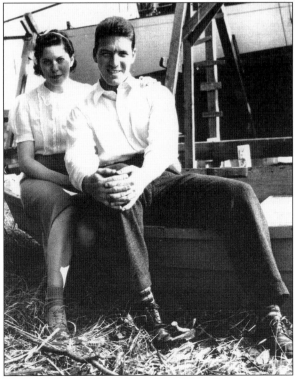

Adele and Robert Burgess came to Newport News because of Bob Burgess's love for the water. Burgess became known as "Mr. Chesapeake Bay." "I loved the water and boats and the Chesapeake Bay. I heard about the new Mariners' Museum, and I thought they might hire me. So I went down on the steamer and took the trolley as far as it would go. The trolley stopped at Hilton, so I walked the rest of the way. The road was just dirt— Warwick Boulevard—but the Museum—it was as if my whole life had been waiting for that place." —Robert H. Burgess. (Courtesy Burgess Family, 1940.)

75

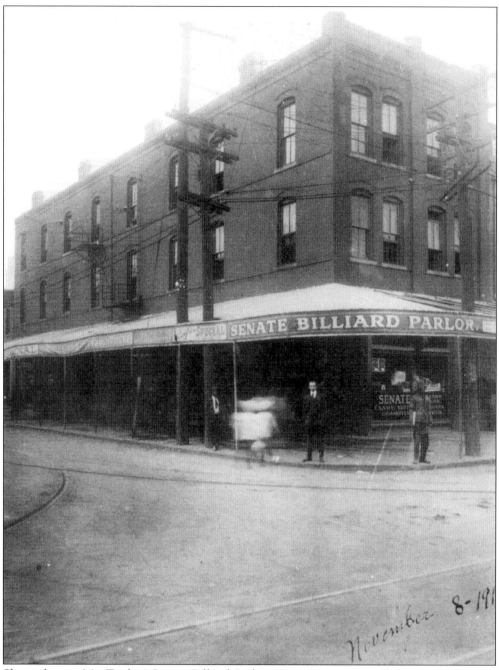

November 8-191

Shown here is Mr. Tirakas' Senate Billiard Parlor, 1919. His was a small downtown business from the good old days, unusual in that he catered to African-American customers. (Courtesy of the Samos Collection.)

Five

SMALL BUSINESSES: HILTON AND BEYOND

"Small businesses are the backbone of America." In Newport News, the very successful small businesses located downtown found themselves the victims of urban planning. Some were able to move on and to succeed, but others were not. This chapter highlights the small businesses that moved away from the juggernaut of the area in the 1950s and the 1970s. The problems they encountered were numerous and diverse. Each owner was forced to make different choices. The seven stories that follow trace the development of businesses in the area and the moves each has made to thrive. It is impossible to miss the feelings of bitterness and sometimes betrayal that some of these businessmen and women feel because of what they perceive as a lack of support from ordinary people and from all the layers of government, some of which are pledged to protect "the backbone of America."

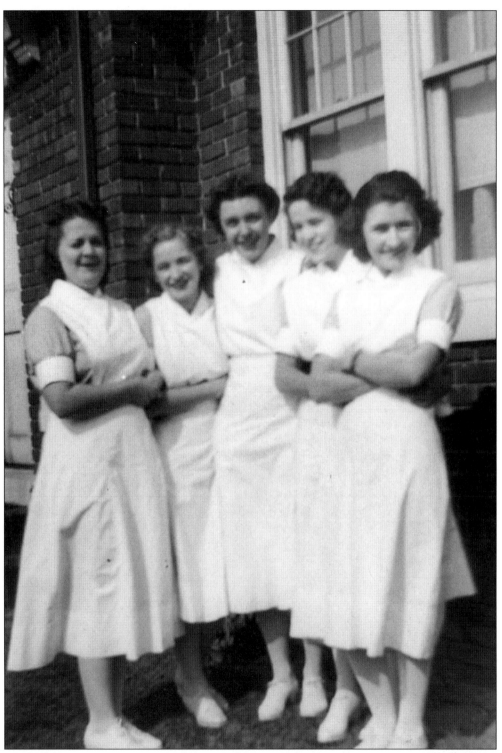

Pictured here are student nurses from the Riverside Nurses Home, shortly before WWII. (Courtesy of the Hoffman Collection.)

Juanita and Maurice ("Mushy") Hoffman, pictured here, met while Juanita was a student nurse. Mushy recalls, "The boys used to go up to the 51st Street area at night to see the student nurses—they were living at the Nurses Home, which was like a dormitory. I was dating somebody else when I saw Juanita. She was so pretty—when I found out she was from Gloucester, I went up to her and just started talking about people I knew in Gloucester." Juanita says, "He was so charming and handsome, and I liked him right away. But it wasn't an easy thing. Mixed marriages—I mean between people of very different religious faiths—they were not approved of in those days. His parents—they didn't even want to meet me. At first, they just wouldn't do it. But eventually they came around, and everything worked out very well." After wartime work in Wilmington, the young family came home to Newport News and started a new life. (Courtesy of the Hoffman Collection, c. 1940.)

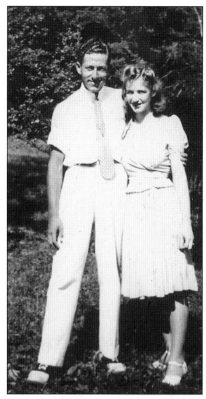

This early ad for "Mushy's Soda Shop" sports a crewcut young man with his pinkie delicately extended over a hotdog. Mushy says, "We started the soda shop in a basement. Then we built our own building across from the Apprentice School—we did cater to those boys. We had magazines and food—chicken and tuna salad sandwiches, hot dogs, ice cream—those boys could eat some ice cream. Then at noon workers from the Yard just poured in." In the 1950s, Mushy and Juanita took a big gamble: they opened The Betti Paige Shoppe—fine apparel for ladies and children. One small business was hard work and two proved even more so. (Courtesy of the Hoffman Collection, c. 1950.)

Pictured here is the window of The Betti Paige Shoppe, dressed for the holidays. While both Mushy and Juanita worked on the businesses, Mushy's daily schedule was brutal. It began at 5 in the morning and he went back and forth between the soda and dress shops until 10 at night. When Mushy could not get home for dinner, Juanita would wake the children when he came home. "It was important for them so see their father every day," she says. The Betti Paige became very popular but Mushy's peripatetic travel on Warwick Boulevard became less popular with the family. They closed the soda shop and focused on Betti Paige. By that time, shoppers from Hampton, Norfolk, Williamsburg, and even Richmond made special trips to the Bettie Paige. The Hoffmans sold the store to their daughter, Judy, and her husband Gayle Rauch, and retired. The Rauchs continued the traditions of excellence and service. Locals thought the Betti Paige Shoppe could survive the changes in the merchandising world. They were wrong. The clothing market for women became too competitive, as department stores picked up specialty lines and catalogues filled mailboxes. Despite the store's excellent reputation, the shop closed in 1994. (Courtesy of the Hoffman Collection, c.1960.)

Pictured here is the Hilton Village's Colony Inn, a quaint establishment that strongly reflected the English character of the surrounding area. The Inn has been long gone, but the character of the area remains. Genuinely unique, Hilton's traditions of neighborliness and community are heartwarming to encounter. The Village has been the focus of restoration efforts, especially in recent years. Numerous small businesses remain in the Village. Before WWI, Hilton Village was farmland. One lone, antebellum farmhouse sat where the Village lies today. The farmer's wife had named the farm "Hilton," which remains the name of the area. The change from farm to village occurred when WWI brought people in from all over the country. Homer Ferguson, president of the Shipyard, appeared before Congress to address the area's critical housing needs. As a result, Hilton was the first Federally-funded housing project in the United States. Henry Vincent Hubbard, a famous town planner, laid out the tracts on 200 acres in Warwick County. Francis Joanne, an architect, designed the English-style cottages. Hubbard planned a shopping area on "the village green," shops with apartments above on each side of Warwick Boulevard, which was a dirt road when the development began. Hubbard thought that the owners would follow the old tradition and live above their shops. While many of these shop-and-home combinations have been torn down, a few remain. (Courtesy of the Cones Collection, c. 1940.)

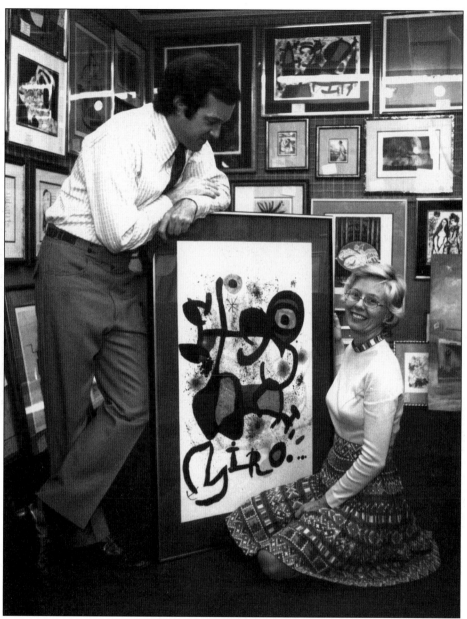

This photo shows customers in the fine Arts Shop and Gallery about 1975. David Sherman's original Fine Arts Shop and Gallery was downtown on Washington Avenue. The collapse of downtown caused Sherman to find a place on the edge of Hilton Village. Mr. Sherman carried old silver, antique furniture, and porcelains. His real passion, however, was modern art. Mr. Sherman had found a Parisian art dealer who supplied prints. Early in the store's Hilton history, a shopper could find original prints from artists as famous as Calder, Braque, Picasso, Klee—many of the ground-breaking artists from the early 20th century. Unfortunately, the market for modern art was not strong in Newport News. In the years since this picture was taken, the Fine Arts Shop and Gallery now emphasizes old jewelry, antiques, and silver. There is almost no modern or contemporary art. Mr. Sherman has died, and both of his daughters, who share ownership of the shop, do not live in town. (Courtesy of the Webb Collection, *c.* 1975)

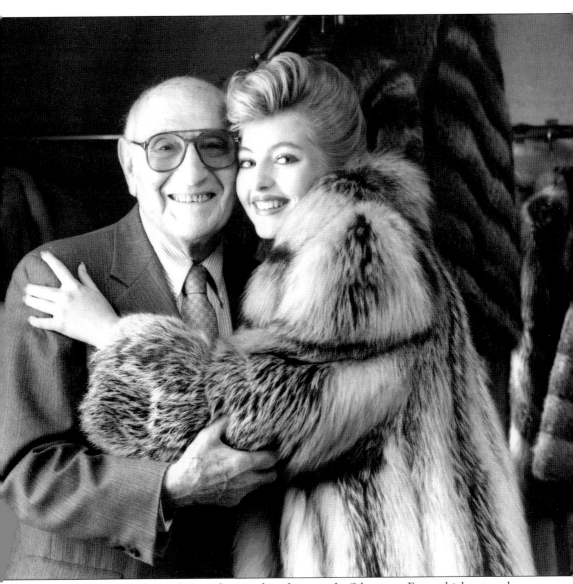

Samuel Silverman admires his product in this photograph. Silverman Furs, which opened on Washington Avenue in 1938, held out against the increasing pressure to abandon downtown until 1976. Then Samuel "Nubby" Silverman remodeled the vacant building where Hilton Pharmacy had stood, turning it into a modern establishment in the heart of Hilton. "Nubby" Silverman was a natural salesman. Cheerful and gregarious, his love of life was instantly obvious to everyone who walked in his store. "One day I went to Silverman's—I had to have a splendid hat, and I had one of my girls with me. She sees a headband of mink, and she waltzes up to Nubby, and she says, 'Mr. Silverman, don't you think I look BEAUTIFUL?' And he said, 'Of course!' She said, 'What can I give you for it?' And he said, 'A hug and a kiss and it's yours!' That's how he was. Louis is a fit heir." —J. Rosenbaum. In 1985, Silverman was picketed by animal rights activists and five years later vandals sprayed his store with animal rights slogans. In response to both events, Mr. Silverman said that he was just as concerned about animals as the activists were and that his furs did not come from endangered species. (Courtesy Silverman Family Collection.)

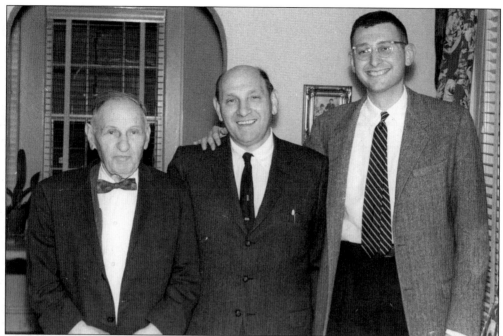

This photo shows three generations of Silvermans: Nubby's father on the left (on a visit from Russia), Nubby, and his son Louis on the right. (Courtesy Silverman Family Collection.)

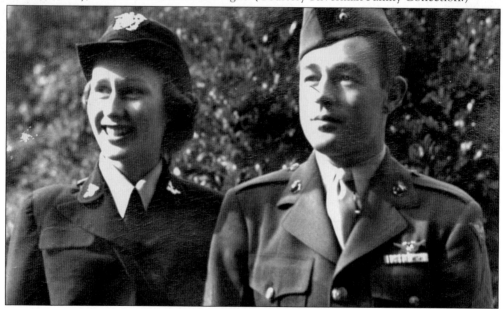

Mary Hunter Parker and Charlie Parker were newly weds in 1944 in this picture. They came home to Newport News after the war, and in 1954, Charlie and Mary Hunter started United Electric on Warwick Boulevard. The shop offers electrical devices of all sorts—from door bells to chandeliers and low-voltage landscape lighting systems. "We did well, very well. We worked with contractors and in the 1980s we were doing a million dollars a year in business." —M.H. Parker. After Charlie's death, Mary Hunter kept on working. In her 80s today, she is working still. (Courtesy of the Parker Collection.)

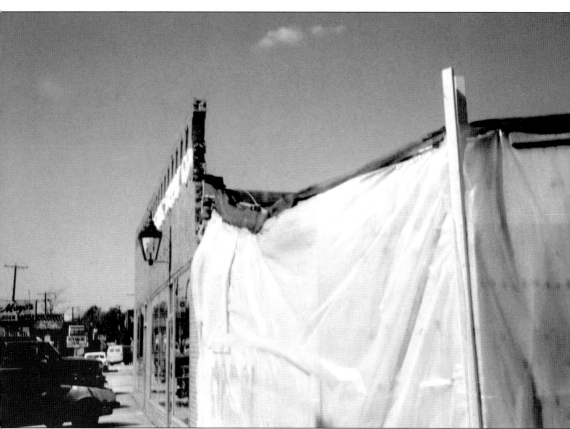

A tarp covers the demolished front wall of United Electric, where a truck smashed into the wall. Mary Hunter was standing at the front of the store when she thought she felt an earthquake. "Then I thought, we don't have earthquakes here! And I ran out. We think the truck driver fell asleep and just ran into the building." The crash bought a great deal of unsought publicity to United Electric, which by then was feeling the sting of competition from the big box stores. (Courtesy of the Parker Collection.)

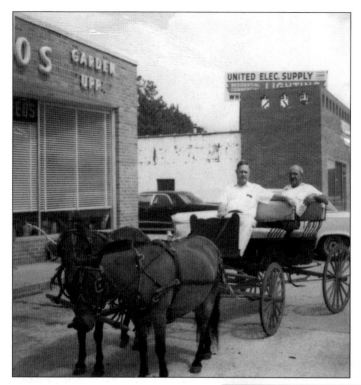

This photo shows United Electric's building, intact, and its sign behind the horse and buggy where Billy Mayo and Johnny Tiller are celebrating the sale of Mayo's Feed and Seed to Tiller. The two shops are separated by a driveway. (Courtesy of the Mayo Family, 1950.)

Martha, the almost life-sized mannequin who was a non-electric fixture at United Electric, was a victim of the truck that ran into UE. Mary Hunter Parker's customers loved Martha. The local newspaper, the Daily Press, covered Martha's injuries, and both UE and Martha became celebrities. Mary Hunter patched Martha up, but soon Martha's owner retired, taking Martha with her. "So many people asked about Martha—I realized I had to buy her. And on the marquee, we put, Martha's Back! It cost me a lot of money. Those mannequins aren't cheap." —M.H. Parker. (Courtesy the Parker Collection.)

Three owners of Jones Furniture appear before their downtown store: Raymond, Billy, and R.R. "Railroad" Jones, their father. To the right is an employee. When WWI broke out, R.R. was called to duty. When the war was over, he went to Newport News and opened Jones Furniture downtown at 30th and Huntington in 1936. His family, which by that time included his wife and three children, lived above the store.

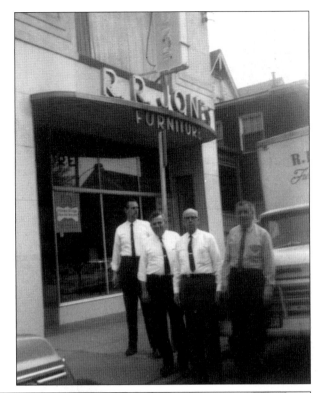

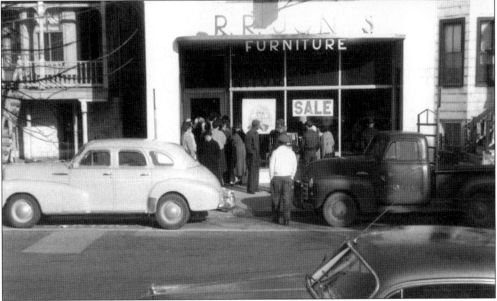

A crowd waits for Jones to open. "Dad started with used furniture. He had just begun to move into new furniture when the second war struck. Times were hard, and furniture difficult to get, so Dad went to New York and brought back truckloads of used furniture. Sometimes we could hardly get it off the truck and into the store, people were so much in need—all the dislocation of war. Look at those people—they are just waiting for the doors to open! Dad always said the secret to success is honest dealing." —Raymond Jones. (Courtesy Jones Family Collection.)

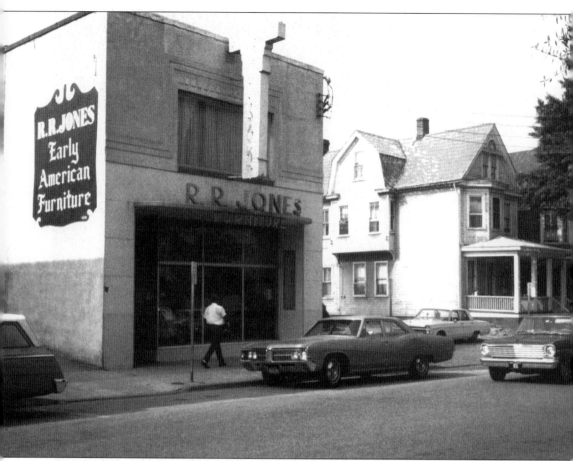

Like all of the other downtown businesses, the Jones' store shown here was displaced in the mid-1950s. With considerable foresight, the business moved to Hidenwood. The move left the family nostalgic for their earlier site. The family name is still visible on the side of that building. R.R.'s sons, Billy and Raymond, were working in the family store. Billy was the vice-president and Raymond the secretary-treasurer by 1967. "We began to bring in new furniture, particularly Early American, and as time went by, we emphasized finer furniture. Dad didn't pay us very well. He gave us stock, but when he died, we discovered that we each owned 50 percent of the store. Eventually, I sold my shares, and now Billy's son is running it." —R. Jones. (Courtesy of the Jones Collection, 1955.)

Hidenwood Pharmacy, shown above,is a few doors from Jones Furniture. It is the direct descendant of B.G. White's Pharmacy in Hilton. Purchased by William Neal in 1948, the drugstore moved to Hidenwood in 1959. Tom Hutchens, who started working for Dr. Neal as a soda jerk, went to work as a pharmacist for Neal in 1962. Tom struck up a friendship with Al Mitchell, and once Al got out of the Army, he and Tom bought out Dr. Neal in 1978. Hidenwood Pharmacy had a soda fountain and a crew of regulars who came in for coffee in the early years. Eventually, the soda fountain proved unprofitable and the store modernized. When Al Mitchell died unexpectedly, Anne Hutchens joined her father when she completed pharmacy school. (Courtesy of T. Hutchens, 1960.)

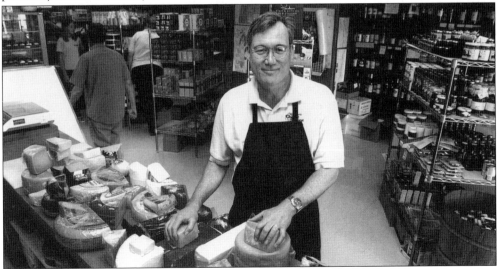

George Ackerman in his Warwick Cheese Shoppe is pictured here. The Cheese Shoppe has been in existence for over 30 years. Both George Ackerman, the current owner, and Tom Powers who started the shop, are experts in wines and cheeses. The store appeals to a fairly elite constituency and has a loyal base of customers. Despite fierce competition from chain stores, the combination of excellence of product and service has allowed the business to thrive. (Courtesy of The Daily Press, 2002.)

The nun pictured is a Poor Clare in the Bethlehem Monastery at Newport News. "Several times a year, one of my customers orders a large box of cheeses and wine to be delivered to the Poor Clares. She sat next to one of the nuns who was flying home—some emergency, because normally the nuns can't travel. My customer was so impressed by the nun that she wanted to do something. So from time to time I put together a large box of wine and cheese—they can't eat meat—and I take it over." —G. Ackerman. Galileo's daughter was one of the Poor Clares, and the order hasn't changed much since it was started in 1212. The nun wears a traditional habit and has bare feet. Her life is lived in poverty and dedicated to prayer. (Photo courtesy the Daily Press, 2002.)

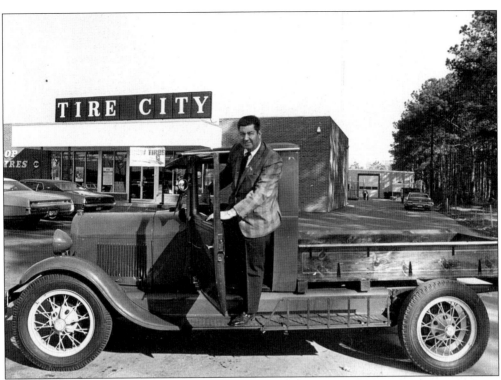

Frank Little is shown here at the opening of the new Tire City Store on Jefferson Ave. Tire City has moved a number of times in its history. Frank Little, the founder of the business, came from North Carolina with $500. He began by recapping tires for government trucks in 1945. His first location was underneath the Wythe Bowling Alley in Hampton. Eventually, Tire City became a large and successful business offering not only new tires but other mechanical services. (Courtesy of the Little Collection, 1958.)

This is one of the many older sites for Tire City. Frank Little had a passion for horse racing, as did a number of his friends. They used to go to the races in Florida by train, playing poker on the way. Little began to race his own horses, and by the early 1970s his horses were among the top ten in the nation. He kept them at the track in Maryland—he was very proud that his trainer also trained Speculative Bid. (Courtesy of the Little Collection, 1950.)

A Seaboard Streamliner with private car speeds to Florida. Perhaps it is carrying poker-playing horse-race fans. (Courtesy of the Rice Collection, *c.* 1950.)

The train is seen coming back from Florida, in early morning mist. "Dad was a hard-working man all of his life. He got up at 4 in the morning—we had moved to Gloucester because of the animals—and he took care of the horses and the chickens from 5:30 to 6:00. Then he came in to work." —R. Little. (Courtesy A.C. Brown, Webb Collection)

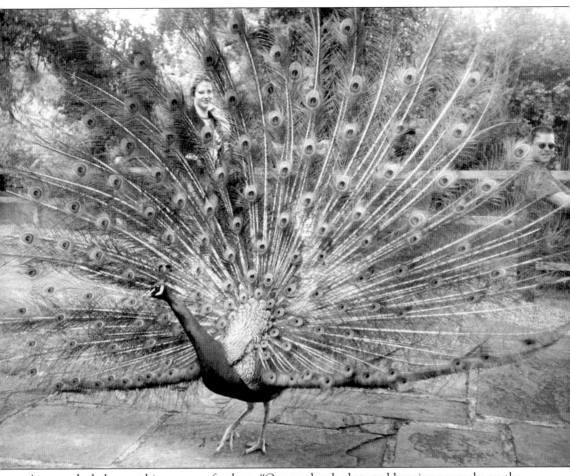

A peacock shakes out his gorgeous feathers. "Our mother had started keeping peacocks on the farm in Gloucester, which is where we all live. Daddy died on a Wednesday. Thursday morning when we got up, there in the middle of those peacocks was a full-grown Albino peacock. Mom said, 'That is your dad. He has been reincarnated!'" —R. Little. (Photo Courtesy of the Webb Collection, 2002.)

"This is a garden where the peacock strays,
With delicate feet upon green terraces,
On leveled lawns and graveled ways,
To watch the motions of the bodily heirs
Of he, who in this lovely place
Spent his store of measured days."
J. Webb, after Yeats.

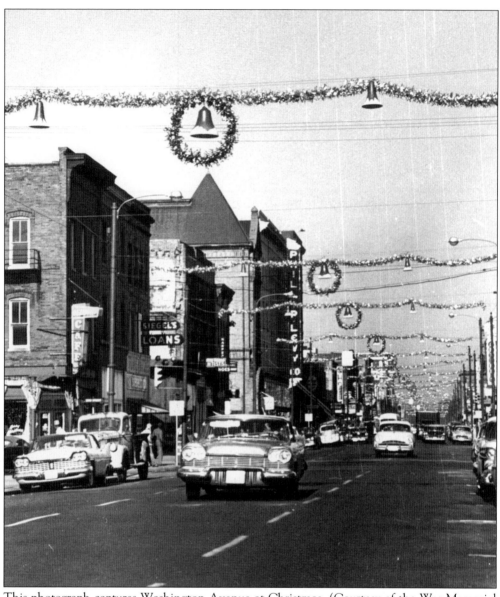

This photograph captures Washington Avenue at Christmas. (Courtesy of the War Memorial Collection, 1950.)

CELEBRATIONS AND HOLIDAYS

For all regions with strong ethnic traditions and long-standing ties to the land and the water, celebration is the spice that makes life tasty. Newport News is no different. The downtown of days past had holiday lights strung across the wide streets. Shoppers swirled through landmark stores such as Nachman's, Barclay's, Rosenbaum's Hardware, and Woolworths. Parents took their children to Richmond, often on the train, to see the windows of the two great stores there. The stores, Thalheimers and Miller and Rhodes, were fixed stars in the holiday firmament. Talking to Santa at Miller and Rhodes seemed to mysteriously guarantee the delivery on the big day of just the right gifts. These once seemingly solid enterprises are all gone today.

In the Greek community, Epiphany and Easter draw on rituals from the European past. For some years, young Greek men here followed the tradition of diving for a gold cross at Epiphany that their fathers had followed on the Aegean shores. Many of these festivals and celebrations are drawn from religious calendars, but just as many are called forth by signals from the world of nature. In this way we are still tied to the signs and portents much as our ancestors.

In our part of Virginia, the first sign of spring is not the dogwood blossoming. It's the shad, surging their way up the river to spawn. The nets strung across the James to catch these silver swimmers work now just as they did for the Native Americans. A single worker hauls the net across the bow of the boat, sorting and releasing into a basket or back into the river. Virginia summers stretch far into the calendar's fall. Crab feasts are the treats of a Newport News summer. Steam them with Old Bay seasoning and the blue tipped shells turn bright red. When the crabs disappear, oysters provide the special tie to the past at fall parties.

The local Greek church celebrated Epiphany by diving for the cross in the early 1970s. The old church was downtown near the water. The picture shows one of the attempts. There was not always ice on the water, but it was usually cold. Church members would parade from the church to the bank of the river. There the Priest would throw the gold cross into the wet darkness and the boys would be drawn by the treasure. Once they lost the gold cross and so switched to wooden crosses. The church has given this celebration up. It is too cold in Virginia. (Courtesy of the Samos Collection, c. 1970.)

Flags are flying for a launching ceremony. Our personal and professional ties to the water give special meaning to the launching of a new ship, of a new yacht, of a small rowboat. Residents love to throw a party for the first touch with the water of even the smallest craft. (Courtesy of the Webb Collection, 1982.)

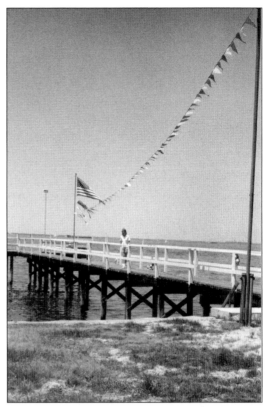

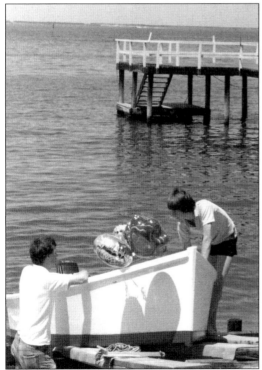

The boat is ready to launch. A young Newport News child prepares to launch his first creation, a 14-foot rowboat, into the river. He has asked his cousin to christen his craft. She will use Virginia's sparkling cider, a break from tradition that is an acknowledgment of her age. Balloons and flags move in the breeze of a bright fall day. His family is proud of the boy's skill. (Courtesy of the Webb Collection, 1982.)

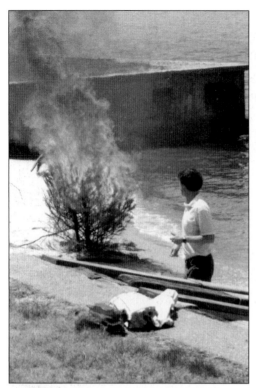

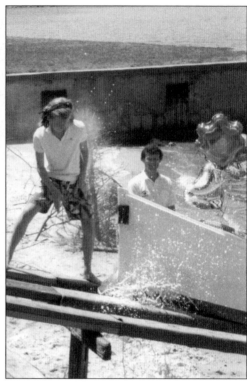

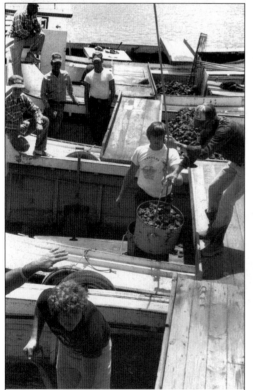

(*above, left*) Tidewater folk often use fire to celebrate. Here the boy's brothers have built a bonfire just down the beach that is blazing its affirmation as well. The lunch and special cake are treats provided by his grandmother. (Courtesy of the Webb Collection, 1982.)

(*above right*) The new rowboat is christened. This boy and his family are playing out a scenario that to Virginia's watermen is a serious rite. One black waterman, Francis Marrow, named his new boat Faith. "You have to have faith to survive on the water," he explained. (Courtesy of the Webb Collection, 1982.)

(*below*) Watermen at Deep Creek stack their boats three deep to unload their oysters. (Photograph by Radcliffe, Courtesy of the Webb Collection, 1980.)

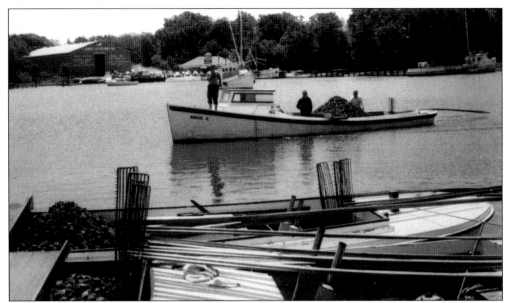

Oyster tongs sit ready for action. The launching of a new workboat to join this fleet is a singular day for the watermen who work the James. Most boats are built in the back or side yards of the watermen, but one special wife gave her front yard to the project. Nearly every day during the long building process someone drops by—not to criticize; just to observe and to talk about the choices being made. (Photograph by Radcliffe, Courtesy of the Webb Collection, 1980.)

On launching day, the friends gather several hours before high tide to check the trailer wheels that have been fastened to the hull. The wheels and the strut that is the tongue turn the boat into its own trailer. Everyone seems to be drinking coffee and betting on just how the boat will float when she hits the water. The art of building, not from plans but by "rack of eye," makes painting the waterline an act of faith and defiance. The builder is asserting his confidence in his craft. The water will have a chance to humble him in just a few hours. (Courtesy of the Webb Collection, 1978.)

A caravan of cars follows the boat, hogging the entire road as it heads for the launch area. The trailer-hull is backed into position at the edge of the water. All activity stops. (Courtesy of the Webb Collection, 1978.)

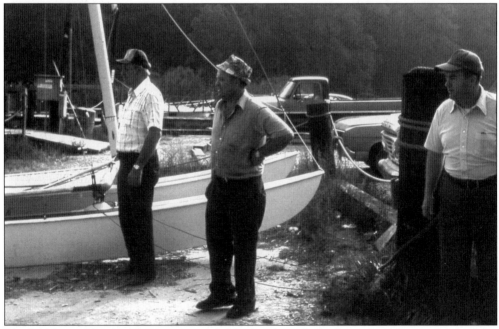

The builder and his friends stare out across the creek, each thinking about the response of this new addition to a fleet that goes back centuries. She is christened and slides into the water, not slowly but quickly as if anxious to try this new world. (Courtesy of the Webb Collection, 1978.)

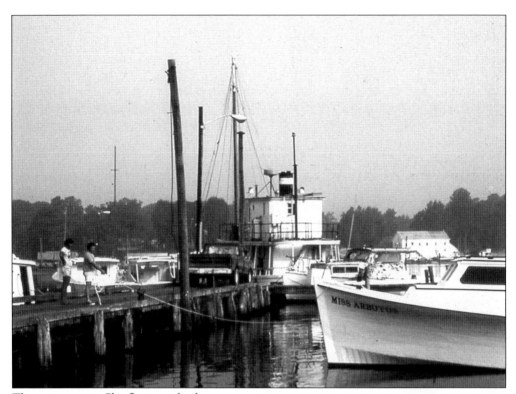

They stare again. She floats perfectly . . . right on her marks. "Just like I planned it!" says the builder. (Courtesy of the Webb Collection, 1978.)

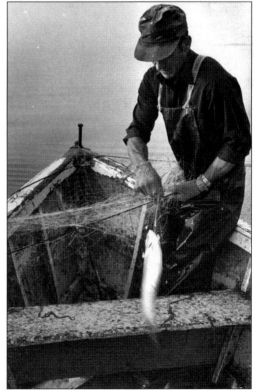

Bobby Brown, a waterman on the James, works intently. In times past, the watermen had a tradition that tied the rhythm of nature with the cycle of the religious year. When Christmas Eve Day breaks clear and cold over the James, the waterman sets off to collect a special gift for his family and his relatives. He starts his motor, and points the bow of his deadrise toward Wreck Shoals. Two hours later he returns, warmed by brisk work on such a chilly day and by the thoughts of his family and his friends. In his boat, he carries five bushels of newly-tonged, still-wet oysters, ready for the baskets awaiting them in the several kitchens of his family. The oysters are the perfect gift for the celebration of Christmas, for they are brought by means of hand labor from the waters that give these men not only their work and their main source of pleasure, but also their identity. (Courtesy of John Edwards, 1978.)

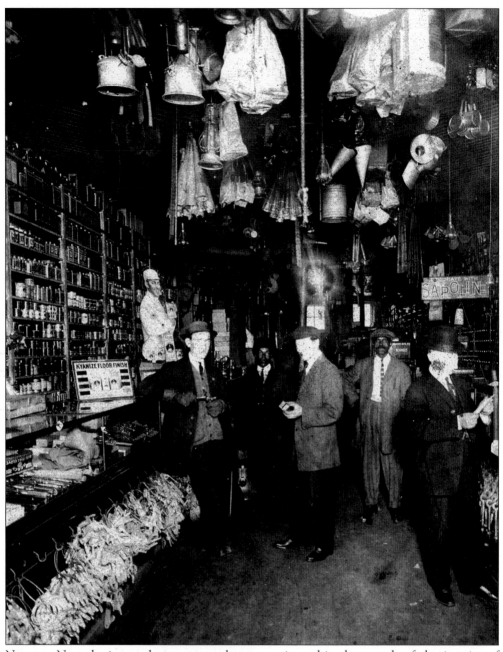

Newport News businesses have come a long way since this photograph of the interior of Rosenbaum's Hardware was taken near the turn of the 19th century (Courtesy of the Rosenbaum Collection.)

Six

NEWPORT NEWS
CREATES ITS FUTURE

Newport News has suffered for many years from the attitude of the surrounding cities. Norfolk and Hampton are both older cities, with rich histories. A Norfolk publication in 1898 made the following observation: "The opportunity was afforded the C&O Railroad . . . some 8 years ago to select a deep-water terminus in the city of Norfolk, but they preferred the more speculative site which they now occupy on the James River . . . We sincerely wish them a good measure of success, for we are satisfied that the development of Newport News into an independent port is impracticable, and its business expansion can only result in the end in making it one of the elements in the final and complete success of our harbor. The cities of New York and Baltimore have as much to fear from the commercial rivalry of their adjuncts as we from our little friend and useful ally in the future, Newport News."

Newport News has been labeled as "a blue collar town" by some residents. Yet Newport News has produced three nationally recognized individuals: Ella Fitzgerald, Pearl Bailey, and William Styron. With the potential of its public schools and its high-tech research lab, the Thomas Jefferson National Accelerator Laboratory, Newport News is preparing to create its future.

William Styron, whose name became a household word due to the movie version of his novel Sophie's Choice, *is the city's most famous native son. Born in June of 1925, Styron lived with his parents at 56 Hopkins Street in Hilton Village. It was here that he carved his initials in a windowsill. According to all accounts, his childhood was not a very happy one. His mother died when he was young. When his father remarried, Styron and his stepmother did not get along.*

The city's future as an economic, cultural, and intellectual entity seems relatively hopeful, anchored as the community is by the Shipyard downtown, the Jefferson Lab in mid town, the rich resources supplied by the museums, and the presence of a university beginning to draw students from all over Virginia.

Shown here is Styron's House in Hilton Village. "I went to school with Billy. He rode on my bus. We used to call him Stinky. He usually didn't tie his shoes, and he wasn't much fun to be with. Nobody was surprised when he went off the Christchurch to boarding school. I don't think he wanted to be here anymore than she [the second Mrs. Styron] wanted him to." —C. Wood. Styron graduated from Duke in 1947 and went to New York to write. In 1951, he published *Lie Down In Darkness*. A novel set in the imaginary town of Port Warwick, strongly resembled Warwick County. Worse, from the point of view of locals, was his use of equally recognizable people. A wave of indignation rolled over the families involved, and both Styron and his work were not popular locally. "I know why they got so mad—you really could SEE them in the characters. But Billy was just using them as a shell. Nobody [in the family he appeared to have used] ever committed suicide, like Peyton. He was just talking about himself. Peyton was Billy, even if Peyton was female." —M. Holt. As the years went by, both Styron and Newport News natives mellowed, with Styron gradually moving to a position of honor. On one of his visits, Styron knocked on the door of his old house and visited with the owners. Looking back, he realized that Hilton had been a great place to be a child—peaceful, tranquil, utterly safe. "If you locked your door, it was an insult to the neighbors." —W. Styron. (Courtesy of Webb Collection, 2003.)

Nathan Isgur served as Chief Scientist and Head of University Relations, Jefferson Lab from May 25, 1947 to July 24, 2001. He is pictured above in this photograph in about 1995. When Nathan Isgur came to Newport News to work in the Lab, the area had gained one of the top physicists in the entire world. Nathan Isgur's life was tragically cut short by a rare form of bone marrow cancer. It was not just his family or the Jefferson Lab that suffered a great loss: it was the world-wide community of physics as well. "After Nathan died, we had calls from everywhere for material for obituaries. Nathan was an exception to the rule that theoretical physicists can't do anything with their hands—Nathan was a very skilled carpenter. Well, I told the reporter from the paper in Houston, Nathan's home town, about his carpentry skills. When the obituary came out, it said that Nathan was such a wonderful carpenter that he had worked on the niobium [metal] cavities—as though you could put wooden cavities inside a superconducting accelerator!" —J. Domingo. The accelerator brought world-class mathematicians and scientists to the area. The resulting rise of small, high tech businesses and their need for scientific and technically trained employees caused a demand for quality in math and science in the area public school systems that has been challenging. (Courtesy of the Jefferson Lab.)

Intermediate Level Students at the Central School are shown in this photograph. All public schools were under the control of Warwick County until the city was issued a charter in 1896. But in 1881, Old Dominion Land Company donated land and loaned money to the county for two schools, one for white students on 28th Street and one for black students on 22nd Street. Both were built in short order. Although these schools expanded quickly from one room to multiple rooms, there was no high school until 1896, when high school classes for white children were offered in a bank building. By 1899, the Central School had been built on 32nd Street and offered classes for white children at all levels of primary and secondary education. (Courtesy of William E. Rouse Memorial Library, c. 1900.)

Atte Hulvey Kennon is pictured here. Her diploma indicates she graduated from Newport News High School, but in the year of her graduation, there was no such school. Her elegant, formal graduation dress shows the importance of a high school diploma in those days. In Newport News for many more years, high school ended with the 11th grade. (Courtesy of the Mays Collection, c. 1900.)

The City Basketball Team is shown here in 1905. Newport News may have been a young town with few educational opportunities, but the 1905 members of the basketball team would later help shape Newport News. Two brothers, both from the McMurran family, would later press forward with development of more than athletics and schools. Central was renamed the John W. Daniel School in honor of a Confederate veteran from Lynchburg. In 1913, it burned and was rebuilt. By 1918, another school, the Walter Reed School, was built to serve the overflow of upper level students from the Daniel School. In 1924, Walter Reed became an elementary school. (Courtesy of William E. Rouse Memorial Library, 1900.)

Newport News Basket Ball Team

This independent entrepreneur is a jelly donut vendor. "When we were kids, there were a lot of vendors. I went to Walter Reed, and a vendor just like this one came by. You could buy three jelly donuts for a nickel! They were so good. My favorite was the deviled crab man—those deviled crabs were the best things in the world. He used to sing out, 'Deviled crabs! John has them!' and you would go and buy. I don't remember what they cost, but there's nothing like them now." —E. Phillips. (Courtesy of the Mayo Collection, c. 1930.)

107

This is Huntington High School, which was built to serve the black community. The public schools in Newport News were known for excellence. Children from other areas came to Newport News schools. Some children paid tuition for the privilege, but since some of the counties—Isle of Wight, for example—had no high schools for black children, the Newport News schools simply took care of them. Joseph Thomas Newsome, a forceful and accomplished black leader and attorney, was a major proponent of a high school that would serve the black community. Huntington High School was built in 1924. That same year, Newport News High School for white children opened. It operated for 50 years and generated intense loyalty among its graduates. With the coming of integration, it was closed as a high school in 1975 and is now in use as quarters for Navy personnel. (Courtesy of the Hampton Roads Chamber of Commerce, *c.* 1930.)

Shown here is Newport News High School. After WWII, the population of Newport News began a steady movement toward the north. The move owed much to urban renewal, designed to rework the business center to create a new industrial dynamic. What happened, though, was that businesses were driven into Warwick County. Newport News needed to recapture a business base and build its professional population. An attempt to consolidate with Hampton failed at the ballot box, and a nervous Warwick County began to feel the hot breath of annexation. When the votes were in, annexation passed overwhelmingly in Newport News. The margin was very slim in Warwick County. Now a larger Newport News moved into the future. The Shipyard effectively took over downtown, and efforts to rescue the heart of the old city met with little success. It was at this point that creative persistence, political energy, and luck took over, and Newport News became the home of a great scientific establishment, the Jefferson Lab. (Courtesy of the Hampton Roads Chamber of Commerce, *c.* 1930.)

This photograph captures workers at the Jefferson Lab installing superconducting cavities, The coming of the Jefferson Lab, originally called the Continuous Electron Beam Accelerator Facility (CEBAF), to Newport News was a coup of the first order. The idea of the continuous beam accelerator had been hatched at the University of Virginia. Many prestigious universities were vying to be its site, not all of them in Virginia. Hans von Baeyer of William and Mary had been tasked with finding some use for an aging research complex on Jefferson Avenue and he urged his agenda on the politicians. (Courtesy the Jefferson lab, c. 1990.)

This groundbreaking at the Jefferson Lab is historic for many reasons. Jessie Rattley, shown here, was the first woman and the first black elected to the City Council, an important event that took place in 1970. She became the mayor and remained in office until 1990, when failure of efforts to revive a downtown once powerful and beloved contributed to her defeat. History is likely to view Rattley's work to help bring the Federal lab to Newport News as her most important contribution. It has brought scientists from all over the world and research dollars to Newport News. The J-Lab occupies land donated by the city. As Hans von Baeyer had hoped, the buildings already at the site provided immediately useful office and lab space. The key to the initial success of the accelerator facility was Hermann Grunder, standing to the right of Rattley, a world-famous scientist and science manager. A man of great charm and a hard driver, Hermann's first step was to assemble a staff. His second was to take an enormous gamble. The accelerator had been designed and funded in a certain configuration. Grunder's intuition told him to change the design. The superconducting niobium cavities are the heart of the design change. Super-cooled, the cavities channel electrons until they reach great speeds, when they are slammed into targets. The collisions give off tiny particles that can lead to new discoveries about matter. A battle royal raged around the design change. Dr. Grunder won. When he left the J-Lab to run the Argonne National Lab, his legacy was impressive. The area's newspapers and other media were the Lab's strong supporters.(Courtesy of the Jefferson Lab, 1987.)

Dorothy Rouse, to become Dorothy Bottom and a driving part-owner of the Peninsula's papers—*The Daily Press* and the *Times Herald*—is pictured as a young child. Pretty, beautifully dressed with her hair carefully arranged for her portrait in the studio, the child removes her shoe, laughing at what may have been the photographer's dismay. Key to shaping any region is its news reporting. The Daily Press began in 1896, and eventually, two families—the Bottoms and the Van Burens—owned not only the two papers but also a radio station, WGH, and the single cable company in town. This empire served the community well. Dorothy's marriage to Commander Bottom was a good match. Commander Bottom became the papers' president and also led the editorial side. When he died in 1953, Captain Van Buren stepped into the presidency. Dorothy Bottom, by that time 57 years old, took over the editorial duties. Strong-willed and determined, she set the editorial policies until she died in 1990. She was 94 years old. (Photo Courtesy of the William E. Rouse Memorial Library.)

This is the loading dock at an early Daily Press Building. Newport News had a long, love-hate relationship with the two papers, which combined eventually as a single morning paper, *The Daily Press*. By the time of Dorothy Bottom's death, she was universally referred to (behind her back) as Big Dorothy. People chuckled over the allocation of two parking spaces at *The Daily Press* that allowed her to park her elegant (and large) cars without damage to nearby vehicles. With Dorothy Rouse Bottom's death, the third generation of owners took over. With this change, the Van Burens and the Bottoms' relationship strained. (Courtesy of the Mays Collection.)

The Daily Press Building in the early 1930s shows the success of the enterprises. But by as the 90s would show, the two owning families could not resolve growing differences, and the local media empire went on the block. It was a sad day for many in the community when the paper and the cable station were sold. (Courtesy of the Hampton Roads Chamber of Commerce, c. 1930.)

This photograph captures the early view of the WGH (World's Greatest Harbor) radio station, the third holding of the Bottoms and the Van Burens. It was cold comfort to the peninsula people, but in fact, the lights of locally owned papers were blinking out all over America. A new nationally owned news corporation is now the reporting heart of the area. (Courtesy of the Hampton Roads Chamber of Commerce, c. 1930.)

Sol Nachman is pictured here. (Courtesy of the Jewish Community Historical Society, 1911.)

THE VIEW OVER NEWPORT NEWS.

Born in Lithuania before the turn of the 19th century, Sol Nachman was one of 13 children. The family left Lithuania via the Baltic Sea, immigrating to the United States. Young Sol was quiet, hard-working, generous, and keenly aware of the need to be involved with the community. He was also ambitious. He started down the path to building a great department store, a dream whose fruition he was not on this earth to see. He died in May of 1929, shortly before the crash, as the consequence of an infection that began as a trivial thing but could not be controlled by the medicine of his time. The family took him to Baltimore, to Sinai Hospital, where he died. As the family was leaving the hospital, they walked by a woman who was leaving with her new baby. Ida Nachman, Sol's wife, turned to her children and said, "You see, that is life."

The following passages, narrated by Mr. Nachman, give a bird's eye view of the community. His character, commitments, and life experiences make him a perfect narrator for this section.

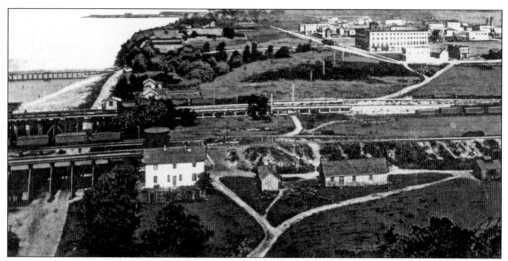

"This is how our town looked in 1887. We are above the C&O terminal, looking to the north. The land is green and peaceful. The roads are all dirt—sandy. There is a pier leading to someone's boathouse to the left. The James River is five miles wide right here. How small is the business section—we are just getting started." (Courtesy of the Cones Collection, 1887.)

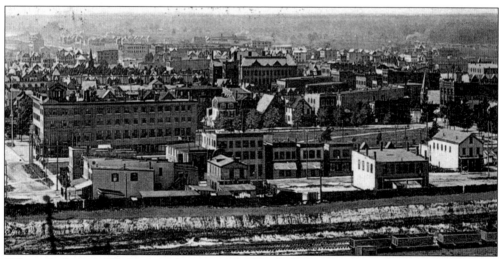

"We are looking up Washington Avenue to the North, from across the railroad tracks. The year is 1906. I have started in business. I know that Washington Avenue is the place one should try to reach. I am going to move a little at a time. One day, I will have my store on Washington Avenue. You see how quickly the buildings have come. We will have a great city here one day." (Courtesy of the Cones Collection, 1906.)

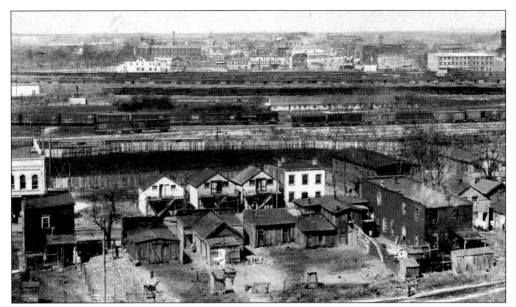

"We are Jewish, and we knew discrimination in Lithuania. We are grateful not to find it here directed against us. But this is not the case for the Negro—you will forgive my antique words, but I have been long gone. The train tracks divide the town, and here you look across the tracks where many of the Negroes live, from the South, to the fine buildings beginning to go up." (Courtesy of the Cones Collection, c. 1920.)

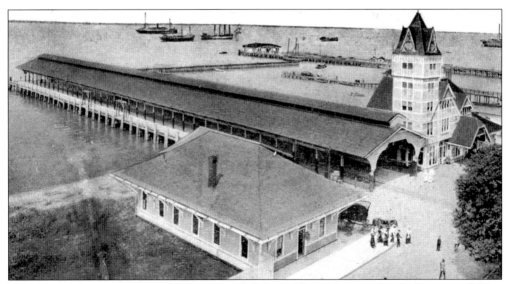

"Ah, here is the entire reason for the town of Newport News when my family first arrived. This is the C&O pier and the train station. In 1908, there are sailing ships in the harbor and the ladies wear long skirts. On the back, 'Tom' writes, 'Dear Sister and all, this station is about five minutes walk from the homes, the waterfront is the James River. It sure is lovely down here now, awful warm in the daytime and cool evenings—Love to All. Tom. Write.' Some things never do change, do they?" (Courtesy of the Cones Collection, 1908.)

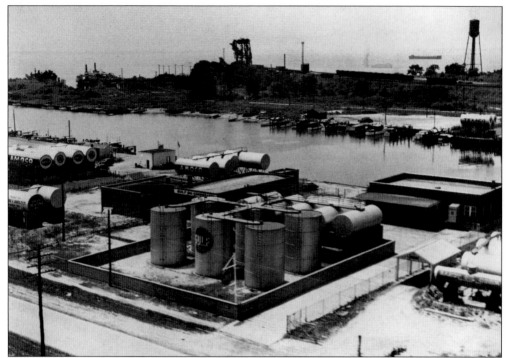

"This Small Boat Harbor housed mainly fishing boats when I came, but this picture shows oil is beginning to be very important to business. On the other side of the water is a crane to load coal onto ships. Coal is one of our chief commodities—I suppose that is still true in your day. You see the large ship far out in the Bay. It looks like a thin cigar, just to the left of the water tower. There are few sailing ships by this time, except for pleasure." (Courtesy of the Hampton Roads Chamber of Commerce, c. 1930.)

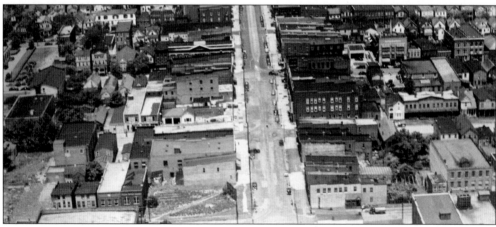

"This is the beating heart of Newport News. Look to the north and you will see three major streets devoted to business and to community. Impressive places of worship have begun to appear. I myself was host to early gatherings of the small Jewish community that came in. Religion keeps men on a straight path." (Courtesy of the Hampton Roads Chamber of Commerce, c. 1930.)

"This is a bridge across the James River. It was opened in 1928. We thought it quite modern, but it did have to be replaced. When I was a young man, floats carried goods and cars back and forth. Commerce between the two sides of the James was important. The farms produced food, and there was a hog industry over there. Hogs were shipped in and out by train and floated across the River. People said the hogs were treated better than the people—they were taken off the train and hosed down in hot weather, then loaded back on." (Courtesy of the Hampton Roads Chamber of Commerce, c. 1930.)

"The C&O Railway Terminal looks so peaceful in this picture, with the two little fishing boats heading up the River. The fish are plentiful and the watermen are a colorful people. The peace is deceiving. If you are on the ground, there is hustle and bustle all of the time. People, goods, produce, commodities—a satisfying feeling of a lively world." (Courtesy of the Hampton Roads Chamber of Commerce, *c.* 1930.)

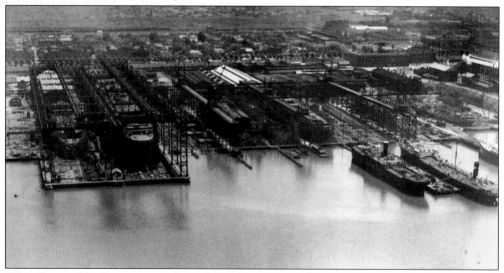

"The Shipyard looks impressive here, but I am sure it will grow even more. Wars alarms will surely sound again and Newport News will take her share of the burdens. Mankind is warlike, it is sad to say and even the best can turn against brothers. On the left, you see ships in the ways, being built. They are not vessels of war." (Courtesy of the Hampton Roads Chamber of Commerce, *c.* 1930.)

"What a difference one family can make—I mean the Huntingtons, father and son, (although when I was alive, only rumor had it that Archer was the natural child of the old man—quite a power, he was, Mr. Huntington, and such vision). Like so many things, this park was part of the plan, but Archer was the one who took it to the next step. He loved history, golf, and art. In the old days, this was a stream that ran into the James. The "bridge" is really a dam. You call it the Lions Bridge, but Anna Hyatt Huntington's famous sculptures are not yet in place in this view." (Courtesy of the Cones Collection, *c.* 1940.)

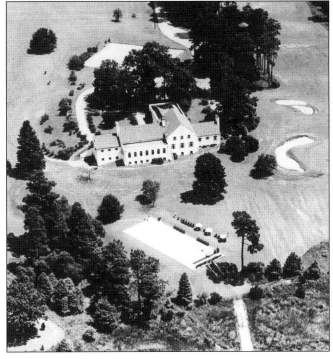

"This is a lovely site, the James River Country Club. One can look right out over the James, which is still very wide at this point. This was not built in my lifetime, so that I did not face exclusion. I understand that things did change for the better, but that it took a long time." (Courtesy of the Hampton Roads Chamber of Commerce, *c.* 1935.)

"This amusing image from what you call a sweatshirt came from the creative imagination of a granddaughter of Michael Hoffman, whom I knew. It has floated up to me that the mother of the gentleman from Switzerland who was a scientist—running the laboratory that is near the train stop where the oysters were picked up to go to the Midwest in my day—said, 'How ridiculous a comparison this is!' One might laugh, thinking of the mighty Swiss, but I suppose each country thinks itself to be better than its neighbors do." (Courtesy of the Webb Collection.)

"Here we see the Aviation Service of Newport News. These pilots, standing by their planes, were among those who flew overhead to allow photographers to snap pictures from the air. One of these photographers was Leo Pugh, the son of L.E. Pugh, who was briefly the president of the *Daily Press Times Herald* from 1928 to 1931, when he died. I was born in a time when none of these things you take for granted existed, or, if they did, were available for the common folk. Amazing, the great changes in life for Americans in a short time—if one thinks of Newport News from 1880 until your present century." (Courtesy of the Hampton Roads Chamber of Commerce, *c.* 1930.)

122

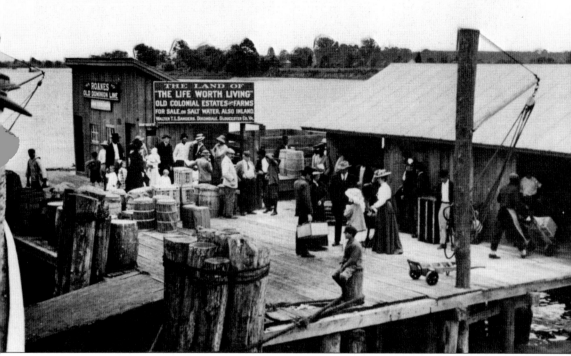

"This sign proclaiming the Land of the Life Worth Living is on a steamboat wharf on a small river not far from here. This is why I came to America. This was for me the land of the life worth living. My dreams were only partly realized in my lifetime, but my family has carried them forward and turned them into realities of which I could not have conceived. The life of no man or woman can be free of pain, loss, sorrow, guilt—such is the burden of being human. But I still believe that in this country, a simple person such as myself, through hard and honest work, has more of a chance to live well and to do good to his fellow man." (Photograph by Hollerith, Image courtesy of The Mariners' Museum, 1901.)

Magic City of the

ILLUSTR

NEW

OF

Golden Gate of the

South.

ATED

1905-'06

ORT NEWS

O-DAY.

Atlantic.

The Magic City is one of several brochures intended to advertise Newport News as a desirable place to live and to work. It was clearly meant to counter the negative comments about Newport News that were coming from neighboring areas, some of which were very disappointed that the C&O terminus was the tip of the Virginia peninsula. Several events, some minor and some major, such as the various wars, from the Spanish American war to the current entanglements overseas and the rampant terrorism, brought from time to time more people to Newport News than the City could easily handle. However, the Magic City certainly was no fiction to the citizens who grew up before the destruction of downtown. (Courtesy of the Mays Collection, 1915.)

EVERYONE COUNTS

All people, great and small, combine their gifts and talents to make a place special. There are four people of whom small snapshots appear below and on the facing page, who have each made some contribution to the place we now call Newport News. The last is a sailboat, handbuilt, rocking at her slip. She is an emblem of the beautiful, of the works of a man's hands, and of the love of the water that has marked so many in Virginia's Tidewater.

Pictured here is Homer Ferguson. (Courtesy Newport News Shipbuilding, 1918.)

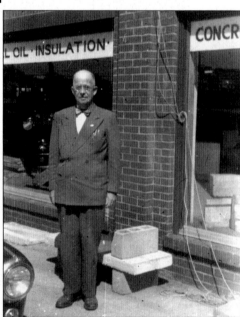

Mr. E.K. Phillips Sr. is shown in this photograph. (Courtesy of the Phillips Family Collection.)

On the right is "Nubby" Silverman
at his birthday party. (Courtesy
Silverman Family.)

This colorful oyster watchman
sits in his small house built
on pilings in the middle
of the James River, 1967.
(Courtesy A.C. Brown, the
Webb Collection.)

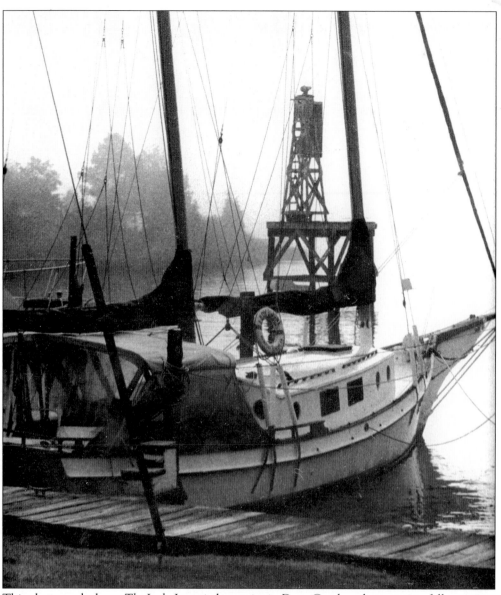

This photograph shows *The Lady June* tied to a pier in Deep Creek early one misty fall morning. (Courtesy of G.R. Webb, The Webb Collection, c. 1980.)

This beautiful lady lightly rests,
the fog floats all around.
She gently sways and waits for one
who now will never come.
For age has bound those cat-quick feet
and crippled up those hands
Like her, he waits—tied up in port—
for a distant spirit land.
His failing heart and failing will
bow to life's last command.